IMAGES
of Rail

UNION STATION IN WASHINGTON, DC

Pi.

IMAGES
of Rail

UNION STATION IN WASHINGTON, DC

Rachel Cooper

ARCADIA
PUBLISHING

Published by Arcadia Publishing
Charleston, South Carolina

Printed in the United States of America

Library of Congress Control Number: 2010942626

For all general information, please contact Arcadia Publishing:
Telephone 843-853-2070
Fax 843-853-0044
E-mail sales@arcadiapublishing.com
For customer service and orders:
Toll-Free 1-888-313-2665

Visit us on the Internet at www.arcadiapublishing.com

CONTENTS

ACKNOWLEDGMENTS

Many individuals and organizations were extremely helpful in providing images and historical information for this book. I would like to offer a special thanks to Edward McCarter, branch chief of the Still Pictures Department at the National Archives and Records Administration (NARA), for helping me locate photographs and providing a great list of resources and additional information. Thanks also to the staff at the Still Pictures Department at NARA; Nzinga Baker and Lisa Klimko of the Union Station Redevelopment Corporation (USRC); the staff at the Library of Congress Prints & Photographs Reading Room; Faye Haskins and the staff at the Washingtoniana Division of the Martin Luther King Jr. Memorial Library; Susan Raposa, technical information specialist at the Commission of Fine Arts; the staff at the Historical Society of Washington, DC, Kiplinger Research Library; Lana Ostrander, director, Marketing and Public Relations at Hargrove, Inc.; Alvin Riddell of Amtrak Corporate Communications; Jacqueline White on behalf of Amtrak's National Train Day; Zachary M. Schrag, author of *The Great Society Subway: A History of the Washington Metro*; and Gladwyn Lopez at Rubenstein Communications, Inc., on behalf of Madame Tussauds Washington, DC. I would also like to thank Marvin Bond, editor of *Recreation News*, for helping me connect with Hargrove, Inc., and John Gervasi of John Gervasi Photography for taking time out of his busy schedule to photograph Virginia Railway Express (VRE) trains for this publication. I really enjoyed working with Arcadia Publishing and would like to thank Elizabeth Bray for her continued support. I also want to thank my daughters, Jennifer and Erica, for their love, support, and patience while I was working on this project. Finally, I want to acknowledge my husband, Brian, and thank him for his love, support, and great photography skills and for inspiring me to continuously take on new challenges.

INTRODUCTION

Washington's Union Station was built in 1907 as part of the McMillan Plan, an architectural plan for the city of Washington that was created to improve upon the original city plan that was designed by Pierre L'Enfant in 1791. At the time Union Station was built, it was the largest train station in the world, with the terminal occupying about 200 acres. Over the past century, the building has evolved into a transportation hub, an upscale shopping mall, and a venue for international exhibits and cultural events. Union Station has an intriguing history, and its construction had a major impact on Washington's urban development.

In 1791, Pres. George Washington appointed Pierre L'Enfant, a French-born American architect and civil engineer, to design and oversee the planning and development of the 10-mile square of federal territory that would later become the District of Columbia. The L'Enfant Plan specified locations for the Capitol and the White House and laid out diagonal avenues intersected with streets running north-south and east-west at circles and rectangular plazas that would provide open spaces. Over time, as the federal government and the city grew, the plan would need to be updated to keep pace with the needs of future generations.

In 1831, the State of Maryland granted the Baltimore & Ohio Railroad a charter to build a rail line from Baltimore to Washington, DC. Throughout the next century, rail transportation was the primary way to travel and transport goods between cities along the East Coast. Washington, DC, built two train depots located within a half-mile of one another. The Baltimore & Potomac Train Station was located at Sixth Street and Constitution Avenue NW (now the site of the National Gallery of Art West Building), and the Baltimore & Ohio Railroad Station was located at New Jersey Avenue and C Street. By the end of the 19th century, railroad access to the two stations had created as many as 28 dangerous grade crossings at public thoroughfares leading to the city. The trains crossing through the Mall were also a visual impediment to the vista between the Capitol and the Washington Monument.

At the beginning of the 20th century, Sen. James McMillan of Michigan chaired a committee of renowned architects and landscape designers to plan for the development of Washington, DC, and expand L'Enfant's desire to surround public buildings with landscaped parks and open spaces. The members of the commission—chairman Daniel H. Burnham, the designer of the 1893 World's Columbian Exposition in Chicago; landscape architect Frederick Law Olmsted Jr.; architect Charles F. McKim; and sculptor Augustus Saint-Gaudens—were renowned designers of the day. At this time, the city's railroads occupied about 14 acres on what was to become the National Mall. The McMillan Commission produced a visionary plan to relocate Washington's train station and create a monumental gateway to the nation's capital. The plan removed many of the slums that surrounded the Capitol, and Union Station replaced both train stations. Northbound and southbound trains were rerouted underground east of the Capitol beneath First Street. With one of the most beautiful and most spacious passenger terminals in the world and the largest freight yard south of New York, Washington moved to the forefront as a national railroad hub.

Architect Daniel H. Burnham designed Union Station in a style that exhibits monumental grandeur suggestive of ancient Rome and Greece. With its 96-foot barrel-vaulted ceilings, stone inscriptions, and expensive materials such as white granite, marble, and gold leaf, the building is considered to be one of the finest examples of the Beaux-Arts style of architecture. At the main entrance, six colossal statues designed by Louis St. Gaudens express the confident enthusiasm of the American Renaissance movement: Prometheus (for Fire), Thales (for Electricity), Themis (for Freedom and Justice), Apollo (for Imagination and Inspiration), Ceres (for Agriculture), and Archimedes (for Mechanics).

Constructed jointly by the Pennsylvania (PRR) and Baltimore & Ohio (B&O) Railroads, Union Station also served the Chesapeake & Ohio; Southern; Richmond, Fredericksburg, and Potomac (RF&P); Atlantic Coast Line; and Seaboard Railroads. As train travel was the primary mode of transportation at the time, this modern facility offered a wide range of amenities such as a first-class restaurant, bowling alley, mortuary, baker, butcher, hotel, library, icehouse, liquor store, Turkish baths, nursery, and a police station. The building was equipped with a presidential suite that has been used by US presidents and many dignitaries, including King George VI and Queen Elizabeth of Great Britain, King Albert I of Belgium, King Prajadhipok of Siam, Queen Marie of Romania, and King Hassan II of Morocco.

As the popularity of air travel led to a decline in railroad passengers, Union Station began to age and deteriorate to the point that, by the 1970s, it was uninhabitable and in danger of demolition. In the 1960s, city officials considered turning the building into a National Visitor Center, a transportation museum, an air museum, an ice-skating rink, a convention hall, or a grand meeting place plus a shopping center. In honor of the nation's bicentennial in 1976, Union Station was renovated to create a National Visitor Center, with the additions of an elaborate audiovisual experience, a national bookstore, multilingual information booths, and a parking garage. The visitor center functions were curtailed when federal appropriations were reduced in 1978, and controversy over the future of the building continued.

In 1988, Union Station was restored per legislation enacted by Congress to preserve the building as a national treasure. It was transformed into a thriving transportation terminal and commercial center, providing service for Amtrak, MARC Train (Maryland Rail Commuter Service), VRE (Virginia Railway Express), and Washington Metrorail. New retail space was added to include more than 100 shops, 35 fast-food outlets, six major restaurants, and numerous services including shoe repair, car rental services, photograph processing, and foreign-currency exchange. Since its reopening, Union Station has hosted many international exhibits and cultural events, including 70 major dinners and charitable benefits, five presidential inaugural balls, and a variety of concerts and special exhibits.

Future plans for the station include adding a new Greyhound bus terminal to the bus-deck level of the parking garage, extending the H Street streetcar line from Union Station to Benning Road Metro, and additional transportation projects. Today, Washington's Union Station is a symbol of the importance of transportation in the nation's capital and serves as a model for the redevelopment of historic train stations across the United States.

One

REDESIGNING THE
CITY OF WASHINGTON

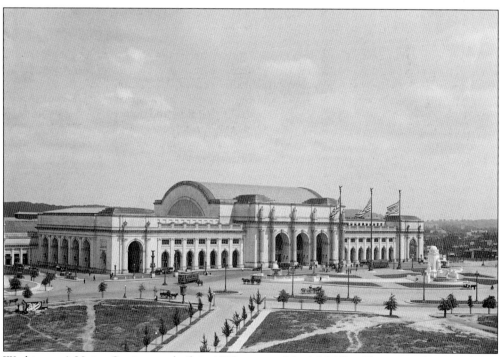

Washington's Union Station was built in 1907 as part of the McMillan Plan, an architectural plan for the city of Washington that was created to improve upon the original city plan designed in 1791 by Pierre L'Enfant. At the time it was built, Union Station covered more ground than any other building in the United States and was the largest train station in the world. (Courtesy of the Library of Congress, Prints & Photographs Division, Harris & Ewing Collection.)

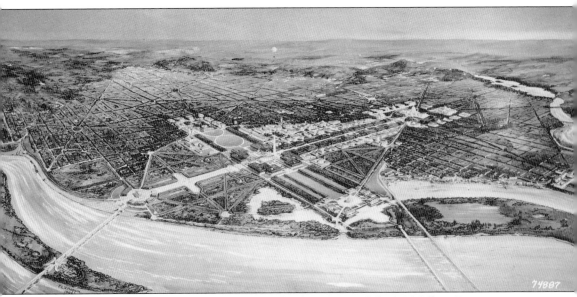

Washington's 100th anniversary prompted the formation of the McMillan Commission to restore the grandeur of L'Enfant's vision to the nation's capital. The 1901 McMillan Plan was a comprehensive city plan that called for an open greenway on the National Mall and removed many of the slums that surrounded the Capitol, replacing them with national monuments and government buildings. The commission was named for its chairman, Sen. James McMillan of Michigan. Some of the greatest American architects, landscape architects, and urban planners of the day served on the commission, including Daniel Burnham, Frederick Law Olmsted Jr., Charles F. McKim, and Augustus Saint-Gaudens. The McMillan Plan created the National Mall as it is today. This image is a drawing of the heart of the nation's capital as it was conceived in 1901. (Courtesy of the National Archives.)

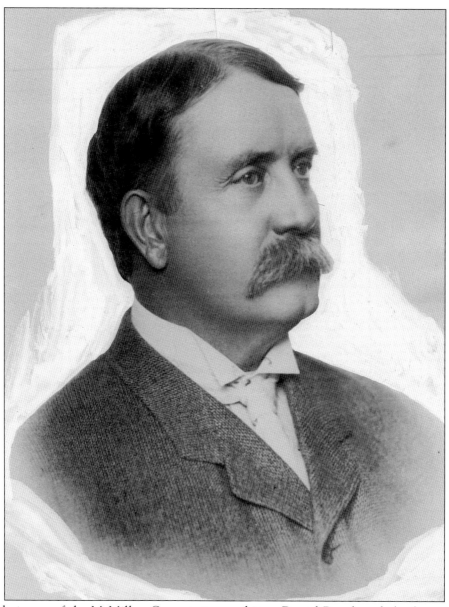

As chairman of the McMillan Commission, architect Daniel Burnham helped create an architectural plan for Washington, DC, that would develop a comprehensive park system for the city. Famous for his work on the World's Columbian Exposition in Chicago in 1893, Burnham created a design to relocate Washington's train station and build a prominent portal to the nation's capital. Burnham's experience designing nearly 200 new buildings of classical architecture for the Chicago World's Fair led to proposals for the Chicago lakefront and river and the first comprehensive plan for the controlled growth of an American city. He was a visionary architect and city planner who built some of the first skyscrapers in the world and developed comprehensive city plans for Cleveland and San Francisco as well as Manila and Baguio City in the Philippines. Burnham was quoted as saying, "Make no little plans; they have no magic to stir men's blood and probably themselves will not be realized. Make big plans; aim high in hope and work." (Courtesy of the Commission of Fine Arts.)

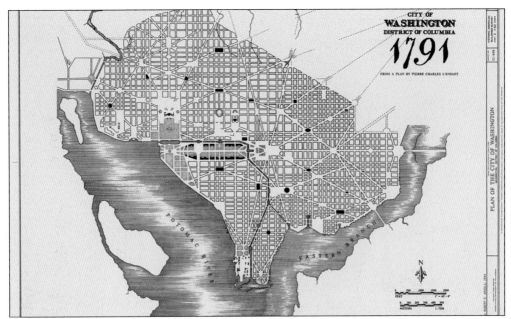

This map shows the original architectural plan for the city of Washington by French American architect and civil engineer Pierre L'Enfant. The L'Enfant Plan specified locations for the Capitol and the White House and laid out diagonal avenues intersected with streets running north-south and east-west at circles and plazas that offered open space. (Courtesy of Library of Congress, Prints & Photographs Division, Historic American Buildings Survey [HABS].)

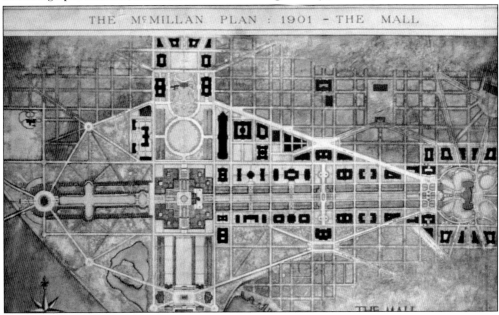

The McMillan Plan of 1901 began the development of a comprehensive park system and created the National Mall, establishing green space surrounding the Capitol, the White House, museums, memorials, and federal buildings. The blueprint attempted to recapture the fundamental principles of the L'Enfant Plan while protecting views, natural features, and the city's water supply. (Courtesy of the National Capital Planning Commission.)

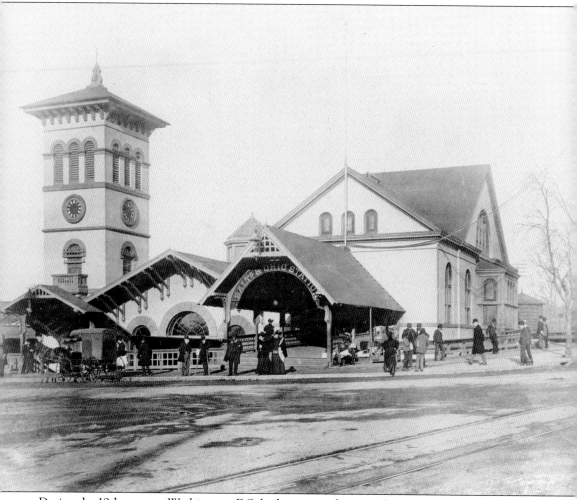

During the 19th century, Washington, DC, had two train depots within a half-mile of one another that were run by two different railroad companies. The Baltimore & Ohio Railroad (B&O) built a station that was located at New Jersey Avenue and C Street just north of the Capitol Building. The B&O was one of the oldest railroads in the United States and the first common-carrier railroad. It was extended from Baltimore to Washington in 1835. Throughout its 180-plus years, the B&O Railroad initiated hundreds of innovative ideas—from operating the first American-built steam locomotive to debuting the first air-conditioned train. In 1963, the Chesapeake & Ohio Railway took control of the B&O, beginning what was to become the Chessie System. In 1980, the Chessie System merged with the Family Lines System to become the CSX Corporation. (Courtesy of the National Archives.)

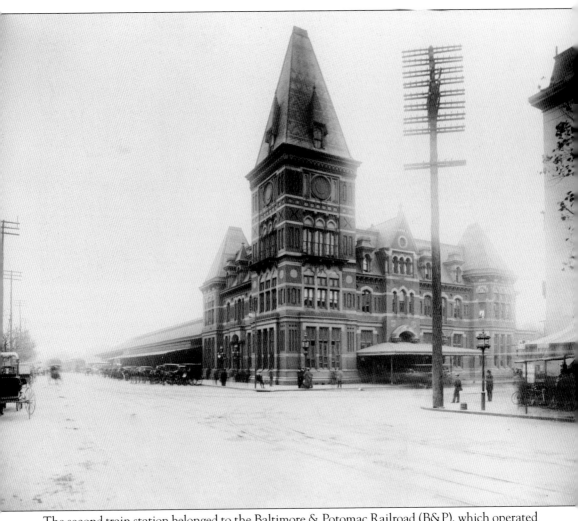

The second train station belonged to the Baltimore & Potomac Railroad (B&P), which operated from Baltimore, Maryland, southwest to Washington, DC, from 1872 to 1902. The company was controlled by the Pennsylvania Railroad and became a major competitor with the Baltimore & Ohio Railroad. The B&P station was located at Sixth Street and Constitution Avenue NW. By the end of the 19th century, railroad access to the two stations had created 28 dangerous grade crossings in the city, and trains through the Mall impeded the vista between the Capitol and the Washington Monument. By relocating the railroad stations and tracks, the National Mall was created and provided public space intended to evoke pride and patriotism. The B&P route was eventually taken over by Amtrak. (Courtesy of the Library of Congress, Prints & Photographs Division.)

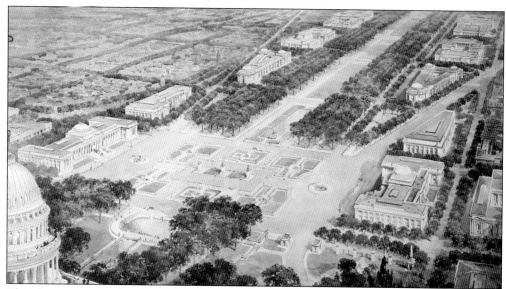

This drawing, created in 1904, shows the proposed plan for the West Capitol grounds and the National Mall. The McMillan Commission planned the construction of civic buildings designed in classical styles with open space surrounding them. The National Mall was designed with scenic vistas between the Capitol, the Washington Monument, and the White House. (Courtesy of the Library of Congress, Prints & Photographs Division, Detroit Publishing Company Collection.)

The McMillan Commission selected the site for Union Station along Massachusetts Avenue at the intersection of Delaware Avenue and First and E Streets. The station would face southeast toward the Capitol, with the tracks running to its rear and out of view. Construction of the building began in 1903 and was completed in 1907. This drawing shows the street plan for the structure and the immediate area surrounding it. (Courtesy of the Commission of Fine Arts.)

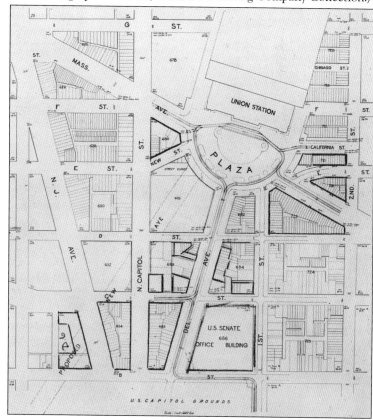

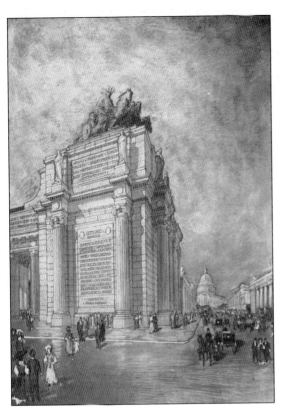

The early years of the 20th century were a turning point for American architecture. Urban planning developed out of the City Beautiful Movement, which was a result of Daniel H. Burnham's work at the World's Columbian Exposition in Chicago in 1893. City Beautiful architectural designs created symmetrical arrangements of spaces and structures in classical styles and focused on creating a beautiful city, which would in turn inspire its inhabitants to moral and civic virtue. The McMillan Plan was the first organized expression of the City Beautiful Movement as a means of beautification and social control. Across the nation, cities adopted these principles with the construction of public buildings, museums, and railroad stations. These sketches show the design for Union Station as an elegant gateway to the nation's capital. (Both, courtesy of the Commission of Fine Arts.)

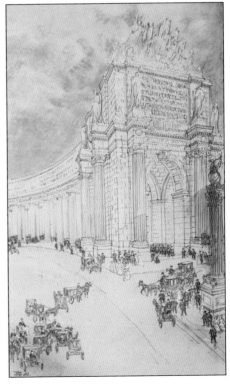

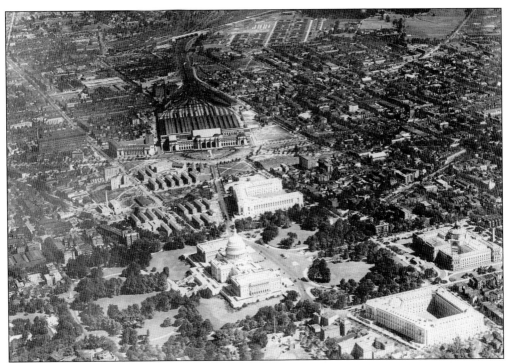

Union Station was built to face directly down Delaware Avenue and provide a clear view of the US Capitol. The railroad tracks were set behind the station and underground so that they would no longer run through the Mall. This 1918 aerial view shows the Capitol, Union Station, and the surrounding area. (Courtesy of the National Archives.)

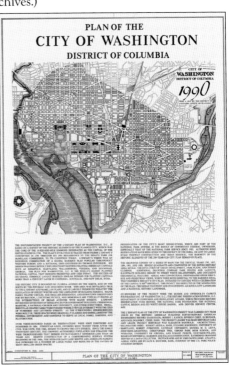

L'Enfant's plan for the city of Washington has been expanded over the 200 years since its design with the reclamation of land for waterfront parks, new monuments, a legally enforced height restriction (the Heights of Buildings Act of 1910, stipulating that a structure's height should not exceed the width of the street plus 20 feet) and open space allowing for scenic vistas. Today, the National Capital Planning Commission is dedicated to planning and improving the National Mall to sustain it for future generations. This image shows the city plan in 1990. (Courtesy of the Library of Congress, Prints & Photographs Division.)

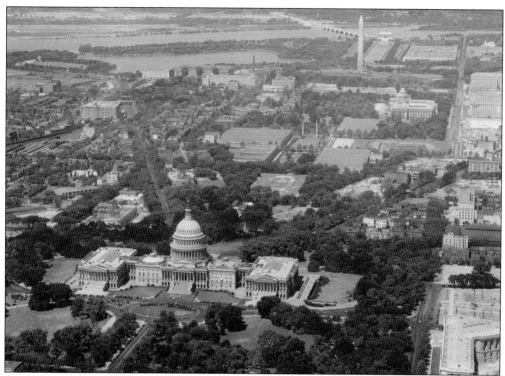

Relocating Washington's train tracks and creating Union Station enabled the beautification of the federal city. Today, Americans take pride in the National Mall, which serves as the heart of the nation's capital, and more than 20 million visitors come each year to learn about American values, democracy, and culture. The National Mall is the central point of most sightseeing visits to Washington, DC, and a public space for national celebrations and for individuals to express their First Amendment rights. The tree-lined open space extends from the Washington Monument to the Capitol. Major attractions include 10 museums of the Smithsonian Institution, national monuments and memorials, the National Gallery of Art, and the US Botanic Garden. (Both, courtesy of the National Archives.)

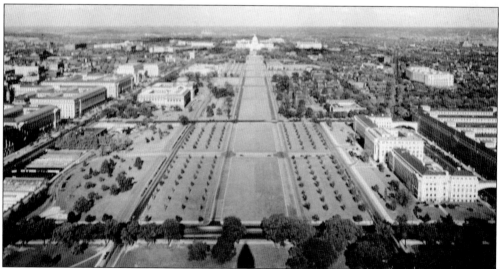

Two

BUILDING UNION STATION

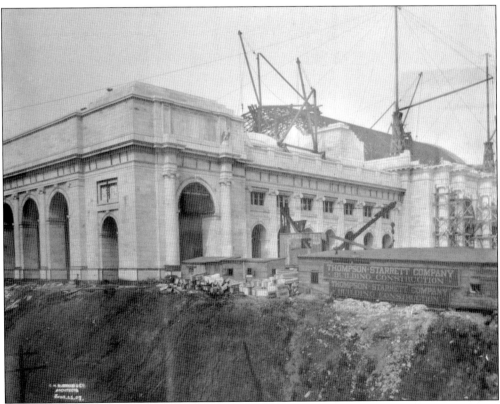

The original construction of Union Station cost more than $25 million, including the tunnel, plaza, landscaping, and rerouting the tracks. The building itself cost approximately $4 million. The foundation was comprised of 20,000 cubic yards of concrete, 30,000 railcar loads of stone, sand, cement, and brick. The combined area of the station and the terminal was 200 acres, including 32 platforms and 75 miles of train tracks. (Courtesy of Amtrak.)

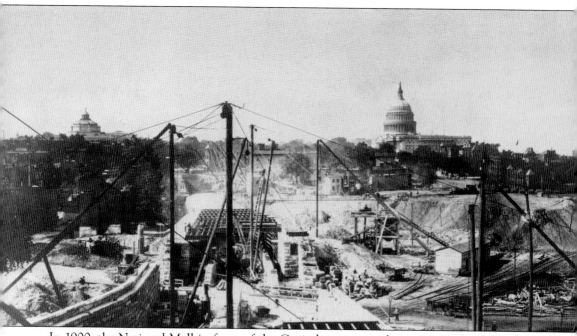

In 1900, the National Mall in front of the Capitol was a complete mess. Railroad tracks cut across it, and shops, buildings, and other random structures obstructed the monumental view that L'Enfant had envisioned. This photograph shows a panoramic view of the 1903 construction site of Union Station. It is obvious that the Capitol Hill neighborhood got its name because the Capitol sits on a hill, though later landscaping dramatically changed the terrain and makes this

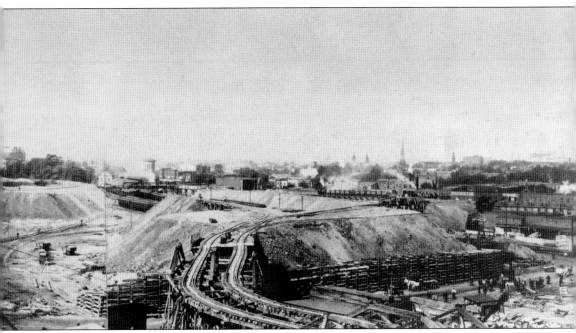

somewhat difficult to see. The construction of the new train terminal required the removal and relocation of 24 at-grade crossings. During this same time period, in 1908, Congress expanded its workspace with the opening of the Russell Senate Office Building and the Cannon House Office Building. Between 1910 and 1935, 61.4 acres north of Constitution Avenue were added to beautify the Capitol grounds. (Courtesy of the Library of Congress, Prints & Photographs Division.)

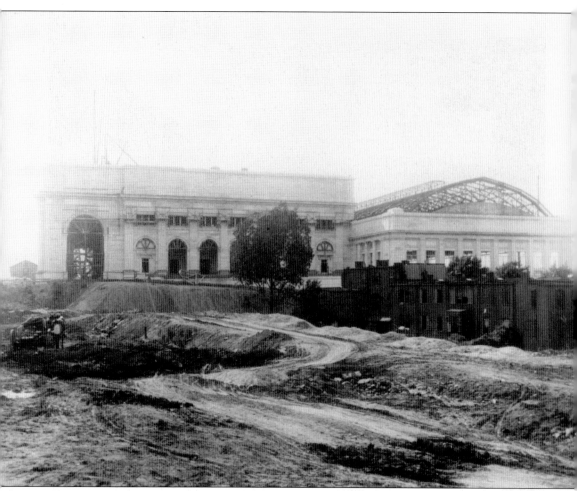

The construction of Union Station began in October 1903 and took four years to complete. The project was a huge undertaking and involved the construction of a massive building and terminal plaza, a tunnel under the Library of Congress, and a train yard complex. The two old train stations were demolished and the tracks relocated. Two tunnels, each 16 feet wide, were dug from Union Station along First Avenue between the Library of Congress and the Capitol, running south about a mile. Burnham brought in Italian laborers and lodged them in camp cars. (Courtesy of the Library of Congress, Prints & Photographs Division.)

These photographs show the neighborhood, referred to as the "Swampdoodle" slum, around Union Station during the early 1900s. The McMillan Plan removed many of the rundown areas around the Capitol so that the federal city would be more impressive to visitors. The massive new station separated lower-class neighborhoods from the central part of the city. As of 2011, the area just north of Union Station is undergoing rapid redevelopment. The neighborhood, known as NoMa (North of Massachusetts Avenue), has received over $1 billion from private developers for office, residential, hotel, and retail space in a 35-block area over the next decade. (Both, courtesy of the Library of Congress, Prints & Photographs Division, FSA/OWI Collection.)

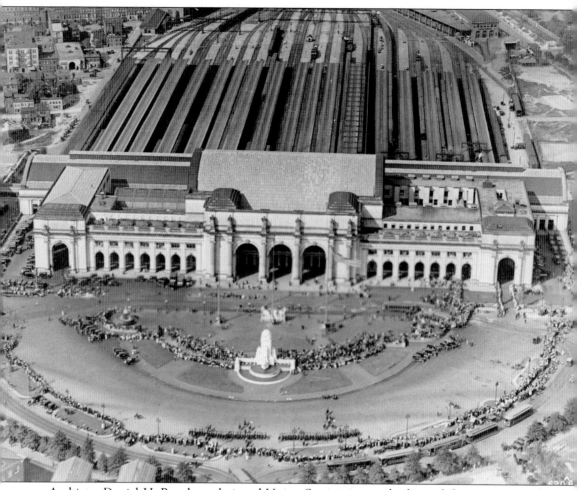

Architect Daniel H. Burnham designed Union Station in a style that exhibits monumental grandeur. The building was designed in the Beaux-Arts style with elements based on the Baths of Caracalla and Diocletian and the Arch of Constantine in Rome. The massive building was the largest construction project in its time and set the standard for Washington's architecture for the next four decades, influencing the design and construction of historic landmarks such as the Lincoln and Jefferson Memorials, the Supreme Court Building, and the National Gallery of Art. With one of the most beautiful and most capacious passenger terminals in the world, Washington, DC, became a railroad hub served by several major railroads. This aerial view of Union Station shows the train yard behind the building and the Columbus Memorial Fountain and plaza in the foreground. (Courtesy of the Library of Congress, Prints & Photographs Division.)

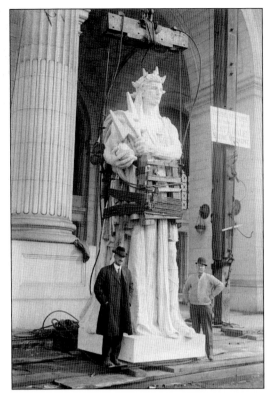

Six 17-foot statues were sculpted by Louis St. Gaudens of Vermont to surmount the pillars forming the arches in front of the main entrance to Union Station. Modeled on the Dacian prisoners on the Arch of Constantine, the statues express a confident enthusiasm associated with the American Renaissance movement. Inscriptions over the arches, called the Progress of Railroading, were selected by Charles W. Eliot, the president of Harvard University. These photographs show the statues as they are being positioned on the main entrance of Union Station in 1907. (Both, courtesy of the Library of Congress, Prints & Photographs Division, Harris & Ewing Collection.)

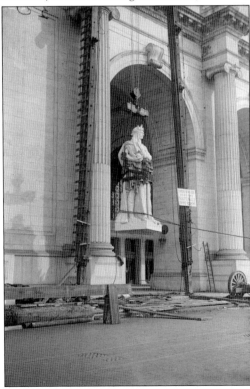

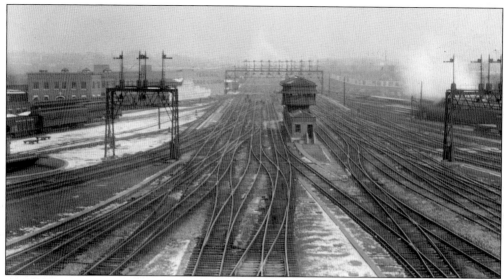

Unsightly yard switching tracks were removed from along Virginia Avenue and the Mall, and the Washington Terminal Railroad created new tracks (above) to provide switching services for station owners (B&O and PRR) and tenants from the south (Chesapeake & Ohio, RF&P, Southern, Atlantic Coast Line, and Seaboard). Thirty-two tracks were built leading to the station: 20 on the main level and 12 below street level. The unattractive tracks across the Mall were redirected through a tunnel under Capitol Hill to Union Station. A 1977 image (below) shows the view of the tracks, platforms, and umbrella sheds behind Union Station. (Above, courtesy of the Library of Congress, Prints & Photographs Division, Harris & Ewing Collection; below, courtesy of the Library of Congress, Prints & Photographs Division, Historic American Engineering Railroad [HAER].)

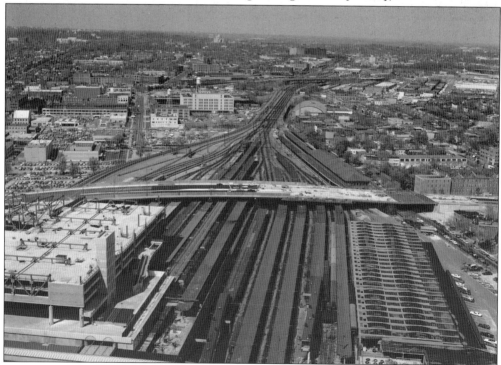

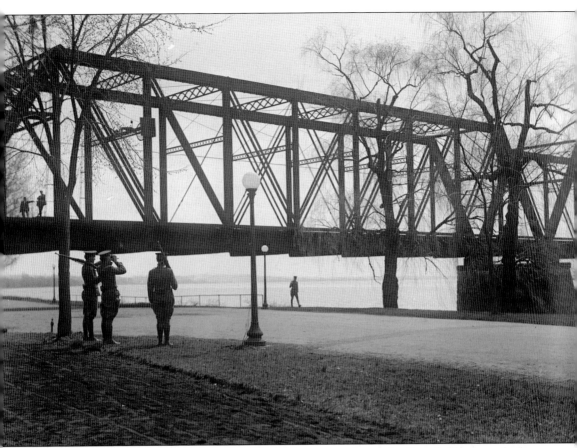

Throughout the 19th and the early part of the 20th centuries, several railway bridges were built around the capital region to provide a way for trains to cross over the Potomac and Anacostia Rivers. This photograph shows the 1904 railroad bridge with 13 spans (one swing span) rebuilt over the site of an 1864 bridge going from Fourteenth Street SW in Arlington, Virginia, through the northern tip of what is now East Potomac Park. The Long Bridge, as it is named, was later rebuilt in 1943 with new piers between the old ones and the swing span removed, but the bridge is still in place. It was the first bridge built at this crossing and only the second to span the Potomac River. This photograph, taken in 1917, shows guards posted at the railway bridge in Potomac Park. (Courtesy of the Library of Congress, Prints & Photographs Division, Harris & Ewing Collection.)

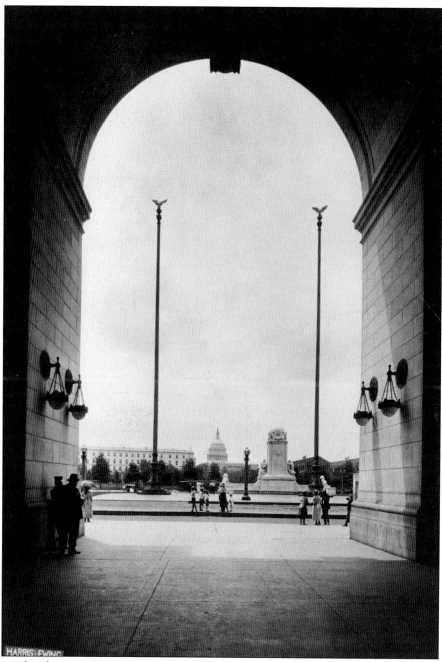

The grand archways at Union Station serve as a symbol of the building's function as a gateway. Architect Daniel Burnham admired Greek and Roman classical designs and incorporated Roman inspirations into the Beaux-Arts structure. The three main archways in front of Union Station were modeled after the Arch of Constantine, located near the Colosseum in Rome and dating to 312 AD. As this photograph shows, a striking view of the Capitol dome in the distance can be seen through the archway at Union Station, reminding visitors of the proximity of the city's train station to the nation's center of power. (Library of Congress, Prints & Photographs Division, Harris & Ewing Collection.)

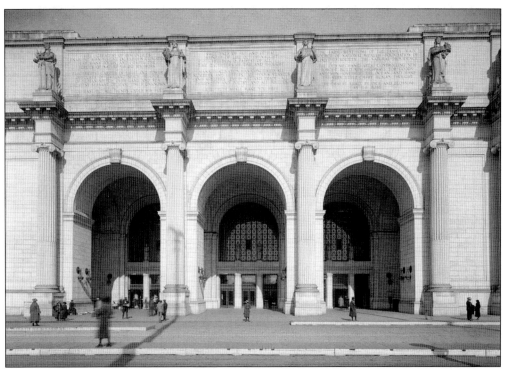

The arches across the front of the building are in three different sizes, each chosen to reflect the importance of that area. The three barrel-vaulted passageways at the main entrance to Union Station are 50 feet high and serve as grand entranceways to the station. Extending right and left are two sets of seven arches, each 25 feet tall, which form an arcade. At each corner is a pavilion ending the building with a single 40-foot arch. All of the arches create an appealing rhythm of light and dark across the front of the station. Triumphal arches are used as interior entranceways as well. (Both, courtesy of the National Archives.)

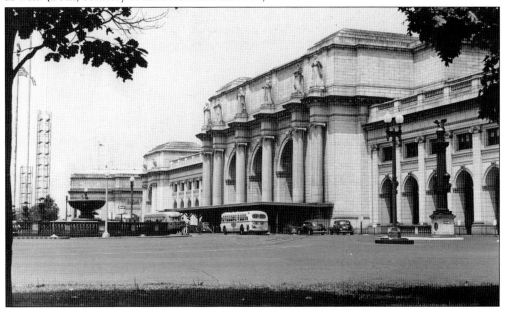

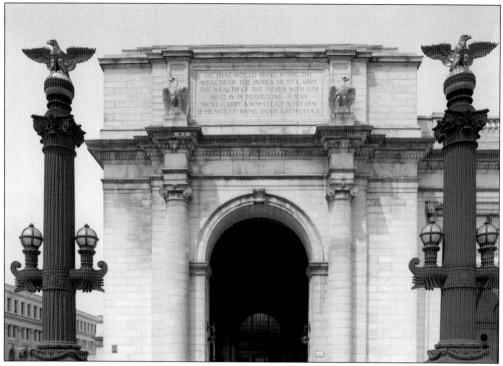

The exterior light poles at the front of Union Station were topped with eagles, representing great power and balance, dignity, grace, courage, wisdom, intuition, and a creative spirit achieved through knowledge and hard work. An inscription over an entrance arch features a quote adapted from Samuel Johnson: "He that would bring home the wealth of the Indies, must carry the wealth of the Indies with him. So it is in traveling: a man must carry knowledge with him, if he would bring home knowledge." (Courtesy of the Library of Congress, Prints & Photographs Division, HABS.)

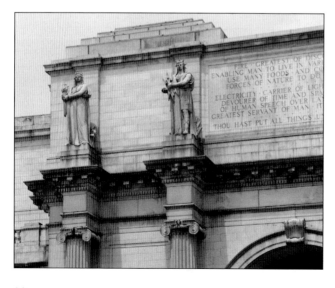

The statues surmounting the pillars in the front of Union Station were sculpted by Louis St. Gaudens and modeled after Dacian prisoners of the Arch of Constantine. This photograph shows details of the statuary and inscription at the west end of the main entrance to the station. The inscription describes the meanings of Fire (Prometheus) and Electricity (Thales). (Courtesy of the Library of Congress, Prints & Photographs Division, HABS.)

Inside the Main Hall, 36 figures of Roman legionnaires stand around the ledge of the balcony. They were originally cast as nudes, but as to not offend the public, railroad officials ordered a shield to be placed in front of each one. The statues remain there today and draw the visitor's eye to the vaulted space. (Courtesy of the Library of Congress, Prints & Photographs Division, HABS.)

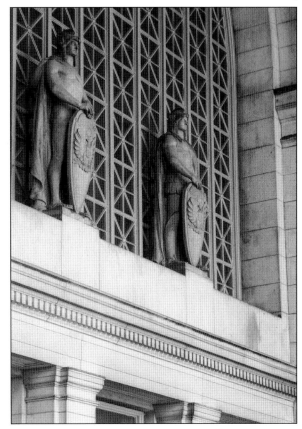

The architectural design of Union Station included many lavish features to provide arriving visitors with an impressive introduction to the city. Following completion of the station, the property surrounding the building was designed as a plaza to leave room for special events. The section in front of the building was landscaped with a beautiful rose garden. (Courtesy of the Library of Congress, Prints & Photographs Division, HABS.)

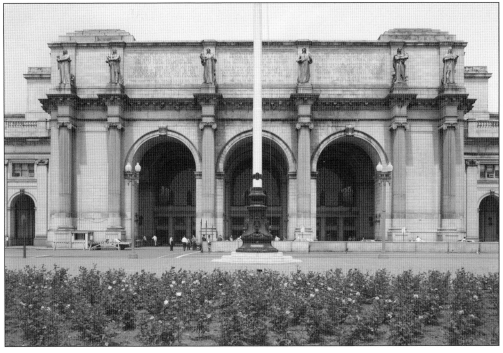

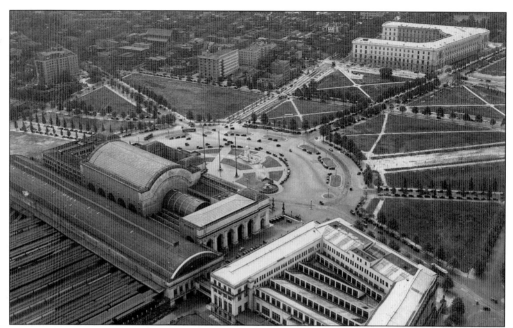

These 1931 aerial views of Union Station provide a perspective on the massive size of the building, the plaza, the rail yard, and the surrounding area. The old Post Office Building (currently the Smithsonian National Postal Museum) is the structure next to Union Station on the right, and the Russell Senate Office Building is the larger building seen in the distance. Prior to the construction of Union Station, rail transportation made the city dirty and noisy. By relocating the station and the railroad tracks and creating a beautiful and spacious passenger terminal, Washington became one of the busiest terminals on the East Coast and expanded its service to include seven different railroads. (Both, courtesy of the National Archives.)

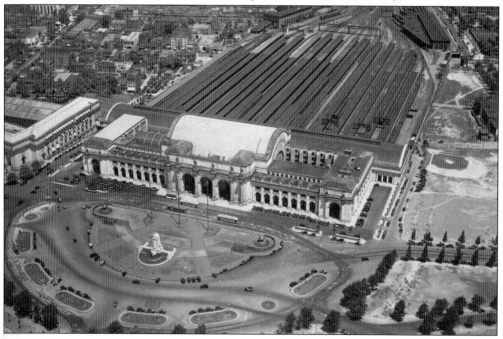

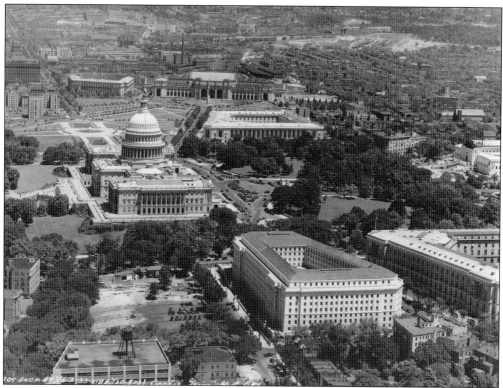

This is an aerial view of Union Station, the US Capitol, and the Potomac River from above the New York Avenue Metrorail Station. Washington's railroad station was strategically located with a direct line (and a short walk) to the Capitol, and the train switching yard and tracks were placed out of sight so that visitors do not notice them when walking around the downtown area. (Courtesy of the National Archives.)

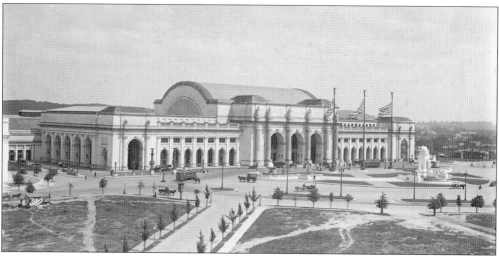

When Union Station officially opened on October 27, 1907, many considered the building to have set the standard for civic improvement in the construction of railroad terminals in the United States. This photograph shows the structure as it looked when it was first completed. (Courtesy of the Library of Congress, Prints & Photographs Division.)

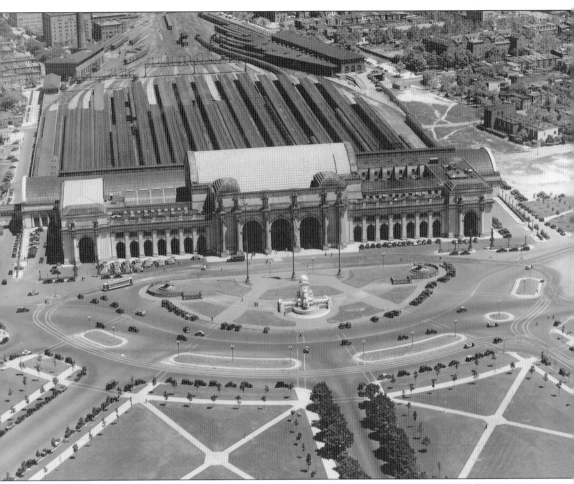

Union Station Plaza was designed as part of the McMillan Plan to carry out L'Enfant's vision of grand spaces and vistas. The layout for the 3.6-acre plaza was an important element of the design for Washington's new terminal. Daniel Burnham felt that a spacious and grand plaza was necessary because most European railroad terminals include a plaza to host events such as greeting important visitors. Over the years, the plaza has been used for many celebrations and parades and to welcome foreign dignitaries and military officers. Union Station Plaza was set up to provide a grand entry for visitors to Washington and to control traffic approaching the station. (Courtesy of the National Archives.)

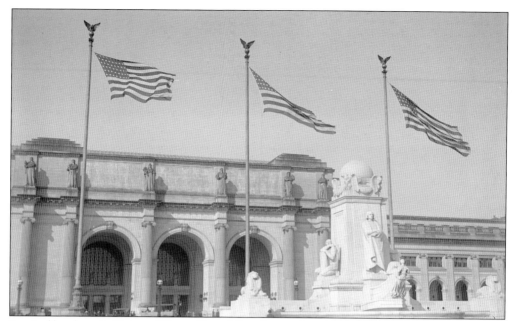

Inspired by plazas in Paris and Rome, Daniel Burnham enlisted Larado Taft, an American sculptor from Illinois, to create a memorial in honor of Christopher Columbus, one of the first Europeans to explore the Americas. The Christopher Columbus Memorial contains three flagstaffs topped with golden eagles in recognition of each of Columbus's three ships from his 1492 voyage. (Courtesy of the Library of Congress, Prints & Photographs Division, Harris & Ewing Collection.)

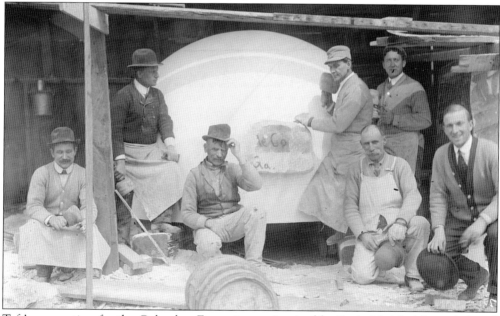

Taft's conception for the Columbus Fountain was inspired by Frederick MacMonnie's famed *Barge of State* at the World's Columbian Exposition. Taft began the memorial on October 26, 1911, and completed it by the end of May 1912. This photograph shows Taft's helpers posed in front of the memorial as they begin sculpting. (Courtesy of the Library of Congress, Prints & Photographs Division.)

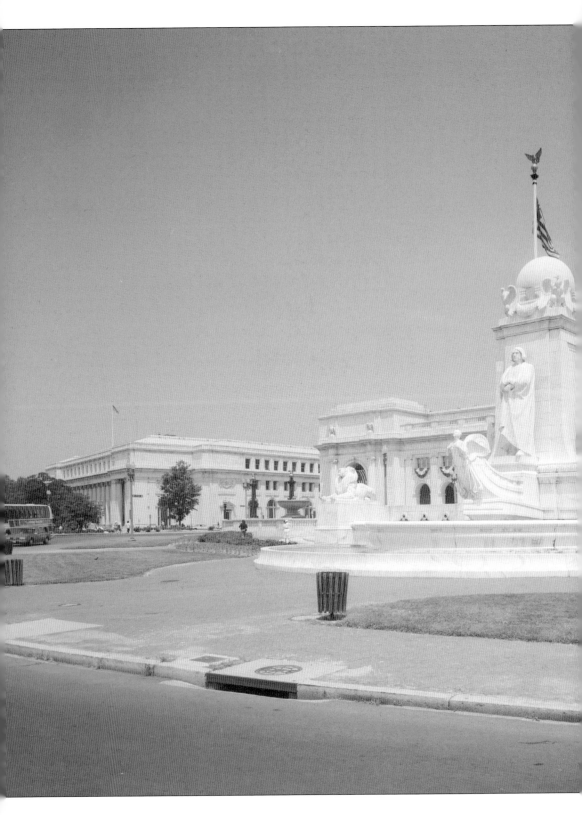

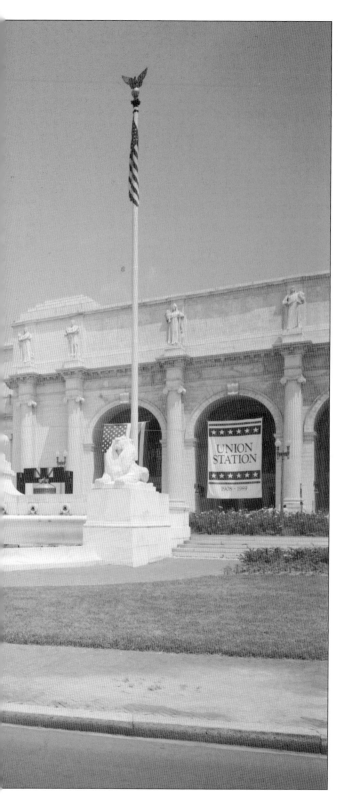

Taft designed the marble memorial as a 45-foot-tall shaft and a large semicircular fountain. With Christopher Columbus standing upon it facing the Capitol, the bow of a ship projects over the fountain from the base of the shaft. Representations of the Old World and the New World embellish the sides of the shaft, which is surmounted by a globe supported by four eagles. The memorial was made of the same granite from Bethel, Vermont, used to build the railroad station. Most of the plaza surface was covered with concrete in anticipation of large ceremonial gatherings. Today, the monument serves as the focal point for annual Columbus Day celebrations. (Courtesy of the Library of Congress, Prints & Photographs Division, HABS.)

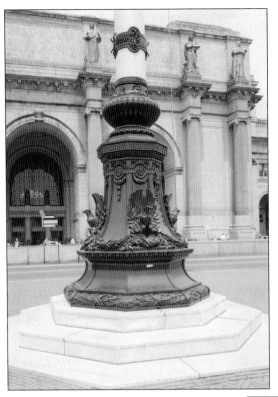

Burnham conceived the plaza as a formal space with elaborate features. Three 110-foot flagpoles with ornate bronze bases were erected near the center of the plaza. This photograph shows the detail of the flagpoles in front of Union Station. (Courtesy of the Library of Congress, Prints & Photographs Division, HABS.)

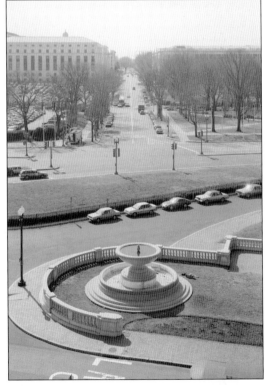

The large semicircular plaza provides an impressive setting for the entrance to Union Station. In 1910, the government acquired 12 city squares between the station and the Capitol to create more parkland connecting the two buildings. Large flower beds were included to break up the mass of pavement. Two large, round fountain bowls were set on each side of the Christopher Columbus Memorial. (Courtesy of the Library of Congress, Prints & Photographs Division, HABS.)

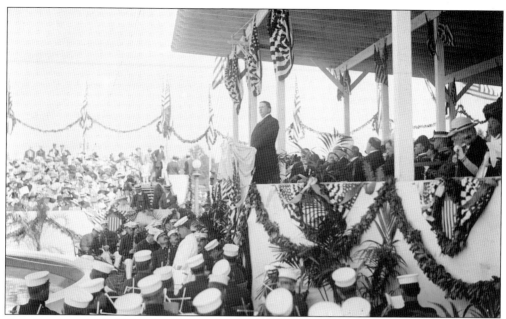

A dedication was held for the Christopher Columbus Memorial Fountain in front of Union Station on June 8, 1912. This photograph shows Pres. William Howard Taft speaking to a crowd at the dedication ceremony. The celebration included a parade with a 21-gun salute and elaborate horse-drawn floats that began at Pennsylvania Avenue and Seventeenth Street and passed in front of the White House before proceeding in front of Union Plaza to Massachusetts Avenue and ending at Stanton Park. Dozens of organizations participated, including divisions and battalions of the Army and Navy, Knights of Columbus, representatives of Italian societies, and members of the African American Knights of Pythias. (Both, courtesy of the Library of Congress, Prints & Photographs Division.)

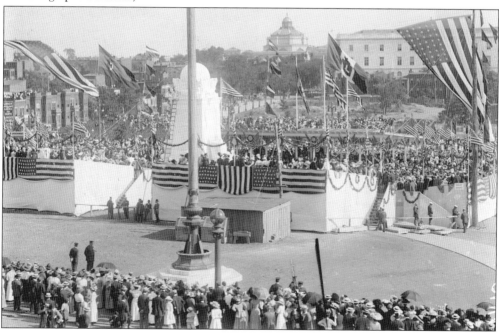

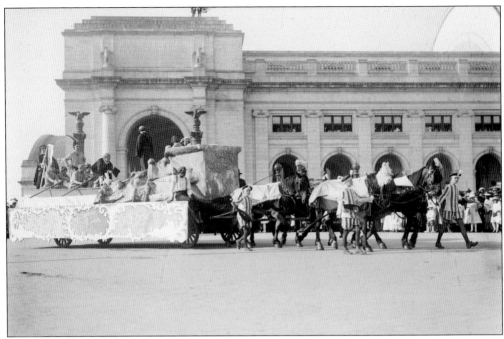

In 1912, the Columbus Day dedication of the memorial included a parade and a few days of festivities. The crowd included 15,000 troops, 2,000 motorcars, 50,000 Knights of Columbus, a 21-gun salute, and elaborate horse-drawn floats. Among the marchers were almost 50 bands and floats representing local and national organizations. In the photograph above, horses pull a float entitled "Departure of Columbus" with reenactors paddling a boat. In the image below, sailors are marching with a giant American flag. (Both, courtesy of the Library of Congress, Prints & Photographs Division.)

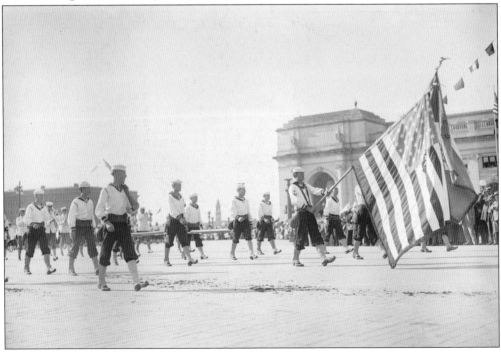

Three

RAILROAD HISTORY

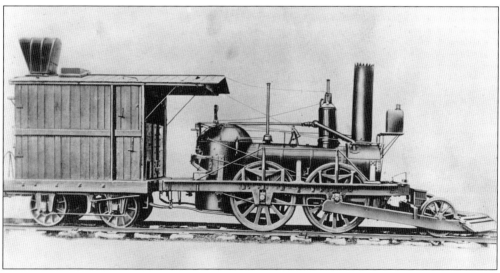

The first railroad came to Washington, DC, in 1831 when the State of Maryland granted the B&O Railroad a charter to extend a line from Baltimore to the nation's capital. The *John Bull* (above) was the first steam locomotive to pull passengers in the United States. It was built in 1831 in Newcastle, England, by Robert Stephenson and Company for the Camden & Amboy Railroad in New Jersey. (Courtesy of the National Archives.)

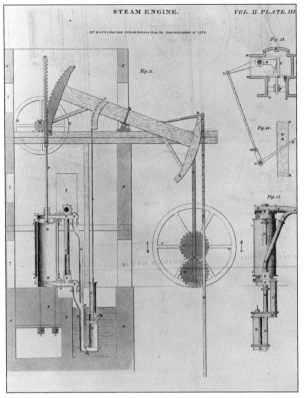

The first railroad cars relied on steam engines for movement. The idea of using boiling water to produce mechanical motion dates back about 2,000 years. A steam engine converts the energy or pressure in steam to mechanical power. This print shows the gears and pump mechanism for a steam engine. (Courtesy of Library of Congress, Prints & Photographs Division.)

Steam locomotives dominated railway usage from the start of the 19th century until the middle of the 20th century. *John Bull* operated for more than three decades and is currently on display as a part of the America on the Move exhibit at the National Museum of American History. This photograph, taken in 1931, shows "Old John" as it marked its 100th birthday by getting up steam and running jacked-up in the Smithsonian in Washington, DC. (Courtesy of the National Archives.)

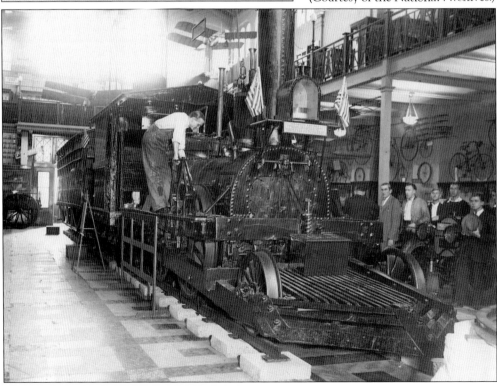

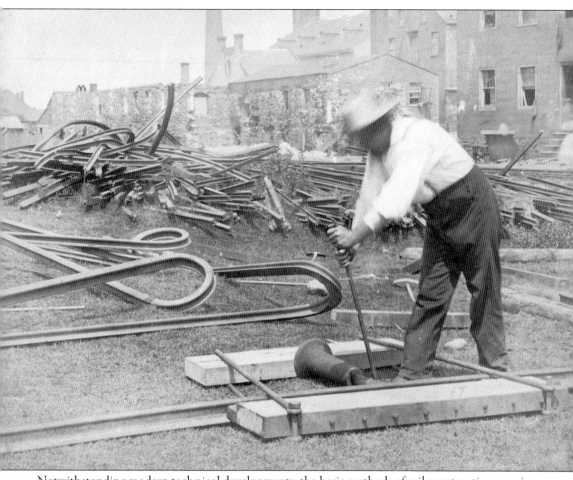

Notwithstanding modern technical developments, the basic methods of rail construction remain the same today as they were more than 150 years ago. Most tracks consists of flat-bottom steel rails supported on timber or prestressed concrete railroad ties, which are laid on crushed stone ballast. The rail is usually held down with resilient fastenings or cut spikes. The cost of building railroad tracks with wooden cross ties and iron-topped stringers was thousands of dollars per mile, even back in the early days of the railroad. Today, in order to the bear heavier and faster trains, the rails are made of specially processed steel and weigh as much as 152 pounds per yard. The cross ties are treated to protect them against moisture and have a life of up to 30 years. This photograph shows a railroad construction worker straightening the track with a pile of twisted rails in the background. (Courtesy of the Library of Congress, Prints & Photographs Division.)

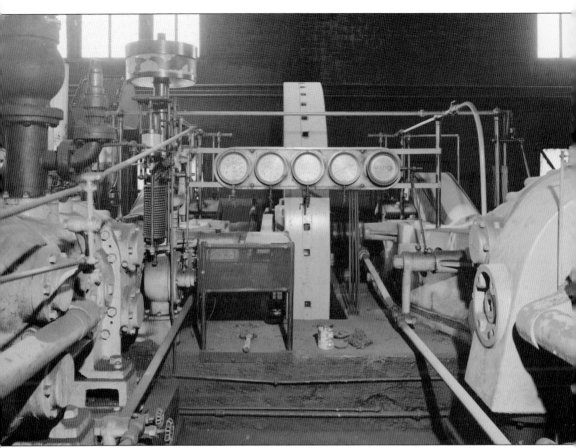

The high-pressure steam for a steam engine comes from a boiler, which applies heat to water. The heat can be derived from various sources, most commonly from burning combustible materials with an appropriate supply of air in a closed space. Steam engines remained the dominant source of power well into the 20th century, when advances in the design of electric motors and internal combustion engines gradually replaced them. This is a detailed view of gauges for steam compressor engines. (Courtesy of Library of Congress, Prints & Photographs Division, HAER.)

This steam power plant was constructed to provide heat and electric power for Union Station and compressed air for the track switches. It was torn down to make way for the Washington Metro system in 1974. (Courtesy of Library of Congress, Prints & Photographs Division, HAER.)

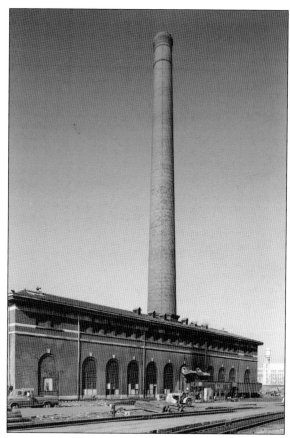

As the years progressed, new and better technologies helped make traveling by rail more comfortable, efficient, and faster. The major conversion from steam to diesel power began in the 1940s. The photograph shows an early steam engine (left) and the first streamlined, non-articulated diesel locomotive, General Motors EMD model EA-EB no. 51, on the Baltimore & Ohio Railroad's *Royal Blue* in 1937 (right). (Courtesy of the National Archives.)

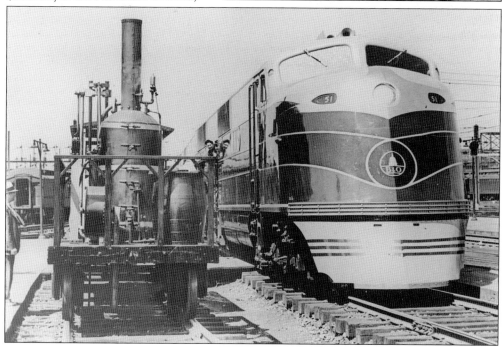

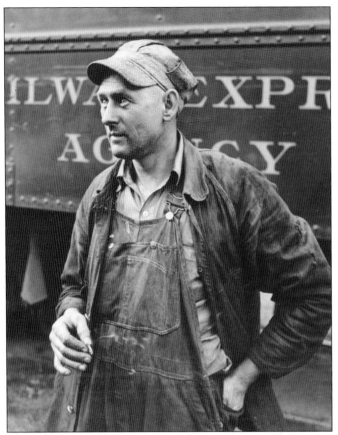

Railroad workers ranged from unskilled freight handlers to locomotive engineers to those who built and repaired the rolling stock. Well into the 20th century, work was unsteady and unsafe. During the 1930s, railroad workers took advantage of new federal legislation to join unions and enjoyed better pay, and railroad work grew increasingly safer. The US Railroad Retirement Board provided railroaders with retirement benefits even before Social Security was implemented. Federal law mandated a 40-hour work week for non-operating workers in 1949. An image (left) shows an engineer on the Baltimore & Ohio Railroad in 1942. An engineer and brakeman (below) pose in the railroad yards in 1939. (Both, courtesy of the Library of Congress, Prints & Photographs Division.)

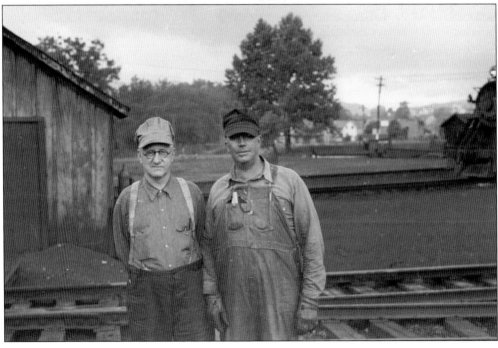

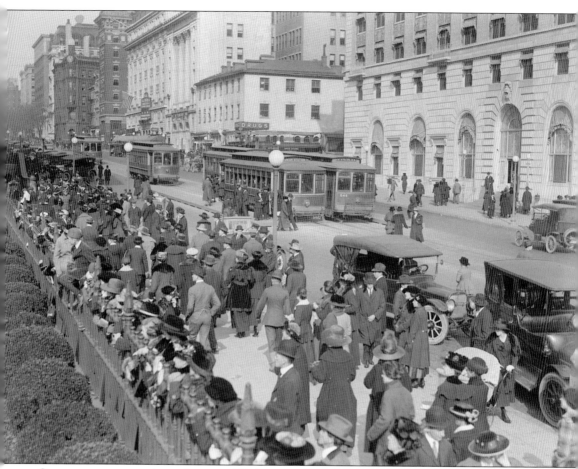

Streetcars transported people across Washington, DC, for 100 years, from 1862 to 1962. Most travelers took the streetcars to and from Union Station, since automobiles were still rare and leaving a horse and carriage for an extended period was difficult. The city's two transit companies, Capital Traction and Washington Railway and Electric, connected the station to the existing lines through three short extensions: one in either direction along Massachusetts Avenue and another from the north down Delaware Avenue. In the peak period of Washington trolley history, there were lines running out to the following destinations: Great Falls (Maryland), Glen Echo Amusement Park, Rockville, Kensington, Laurel, Annapolis, Baltimore, Seat Pleasant, Congress Heights, Mount Vernon, Alexandria, Vienna, Fairfax, Leesburg, Great Falls (Virginia), and Bluemont. (Courtesy of the Library of Congress Prints and Photographs Division.)

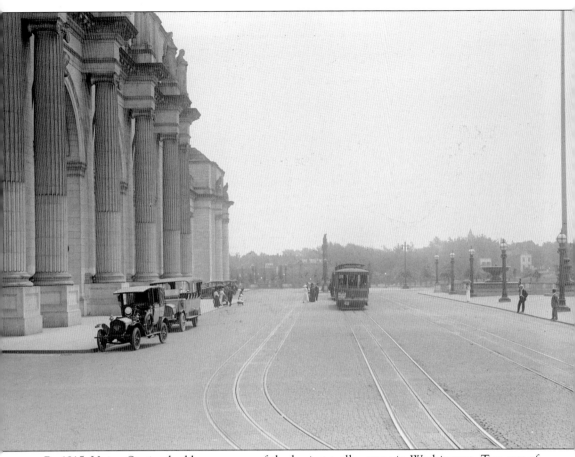

By 1915, Union Station had become one of the busiest trolley stops in Washington. Two sets of trolley tracks circled the outside of the Union Station Plaza, while four ran by the portico—two for normal use and two in case of accidents or for major events. This photograph shows a trolley stopping in front of Union Station to pick up passengers. Several of the streetcar lines extended into the suburbs of Maryland and Virginia. In the 1920s, electric streetcars were used throughout the city and even delivered freight on their railcars. With the popularity of the automobile, trolleys became less popular, and the streetcar companies began operating buses. The city's streetcar system was abandoned in 1962. Much of the track in the District of Columbia was removed and sold for scrap. The complex track work in front of Union Station was removed in the mid-1960s. (Courtesy of the Library of Congress Prints and Photographs Division.)

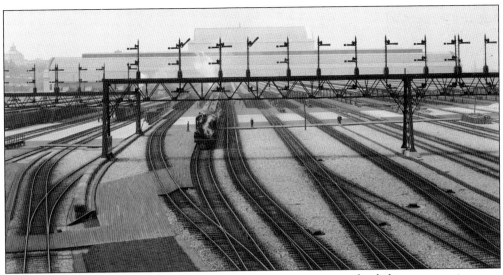

The train yard immediately north of the Union Station concourse was divided into two sections: one a high level for 20 stub tracks; the other a lower level for 12 through tracks. Passenger platforms were generally 20 feet wide and baggage platforms 17 feet wide, both covered by individual shelters. The train yard also contained a main power plant that furnished all the power needed for the operations of the station and yards. The tracks were built to allow for switching (above) so that the trains could easily be moved to an adjacent track. In a close-up of the signals (below), red signals danger (stop), green means caution (slow), white signifies safety (continue on), green-and-white means stop at a flag station for passengers or freight, and blue is placed on equipment that should not be moved. (Both, courtesy of Library of Congress, Prints & Photographs Division, Detroit Publishing Company Collection.)

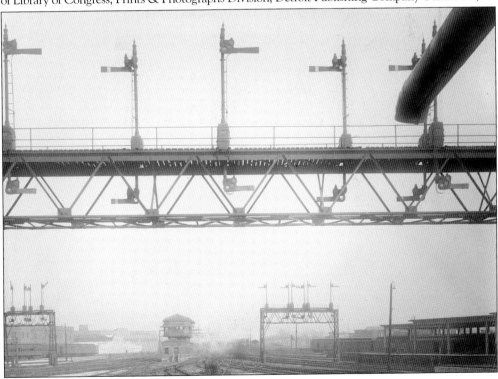

The Anacostia Bridge is a railway-only bridge that crosses the Anacostia River in Washington. It was built in 1904 by the Baltimore & Potomac Railroad to provide a more direct line from Baltimore to the District of Columbia and to connect to the new Union Station. Today, the bridge carries only Amtrak's Northeast Corridor passenger-rail traffic. (Courtesy of Library of Congress, Prints & Photographs Division, HAER, photograph by Jack E. Boucher.)

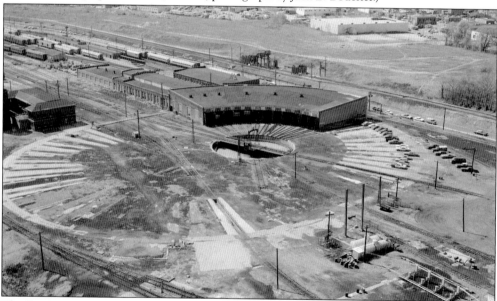

The B&O Railroad built a roundhouse for Washington, DC, one mile outside the city limit, on a triangular strip of land in the central part of the Northeast quadrant bounded by New York Avenue to the northwest, West Virginia Avenue to the east, and Mount Olivet Road to the south. The roundhouse was a large semicircular structure used to service the locomotives. The Ivy City Roundhouse is still used by Amtrak for maintenance. (Courtesy of Library of Congress, Prints & Photographs Division, HAER, photograph by Jack E. Boucher.)

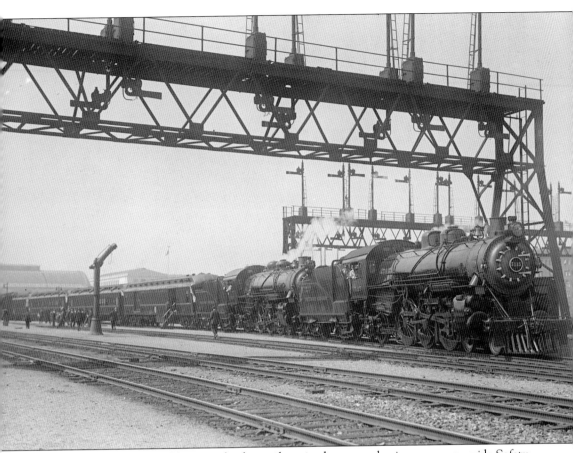

In 1911, the B&O Railroad became the first railway in the east to begin a company-wide Safety First Movement. From day one, railroads were dangerous places to work. Employee injuries were not usually caused by equipment failure or derailment but by worker carelessness. As automobiles became more popular, accidents between locomotives and automobiles frequently resulted in fatalities. The Safety First Movement was a national campaign to warn motorists of the dangers that lurked at railroad crossings. The safety message was reinforced with local committees, slogan contests, and posters. General manager Arthur W. Thompson named a general safety committee and instructed each division to organize safety committees. This photograph shows the B&O Railroad's Safety First train departing Union Station in 1917. (Courtesy of Library of Congress, Prints & Photographs Division, Harris & Ewing Collection.)

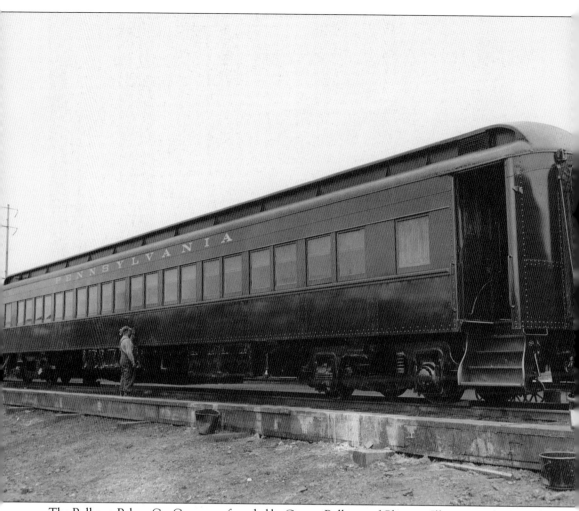

The Pullman Palace Car Company, founded by George Pullman of Chicago, Illinois, revolutionized the train travel industry by providing luxury railroad cars from 1862 through the mid-20th century. The Pullman Company developed railroad cars with elegant restaurants, accordion connectors between cars to keep out wind and noise, and relatively comfortable sleeper compartments with fine sheets and pillows. By the early 1900s, Pullman was the largest builder of both passenger and freight railroad cars in the world, operating more than 7,500 palace cars. Throughout its history, the manufacturer embraced the latest technology, and new cars were equipped with electric lighting, air-conditioning, upgraded dining cars, modern seating, and sleeping accommodations. As rail travel became less popular, the company suffered a slow decline, and it eventually closed in the 1980s. This photograph shows a Pullman car on the Pennsylvania Railroad. (Courtesy of the National Archives.)

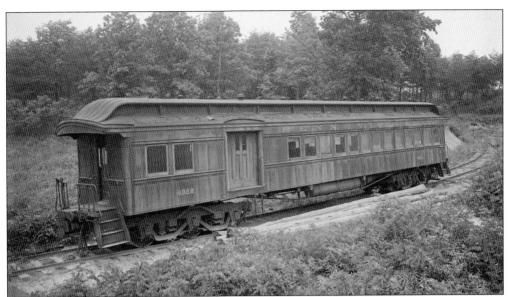

The photograph above shows the Pennsylvania Railroad's 4928, a wooden combine car used around 1915 to 1930. As the name implies, combine railroad cars combined sections for both passengers and freight. Combine cars began to appear on passenger trains not long after the common coach car (featuring side-by-side rows of seats with an aisle running directly up the center) appeared in the mid-19th century. This car has a 20-foot compartment for freight and express at one end and a rear section with walkover coach seats. The six-wheel trucks show that this is a "heavyweight" steel car. The photograph below shows the interior space of the 4928. (Both, courtesy of the Library of Congress, Prints & Photographs Division, Harris & Ewing Collection.)

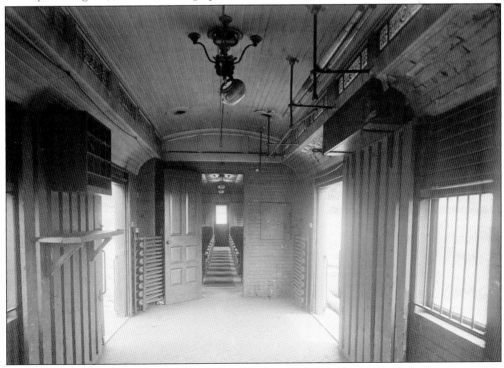

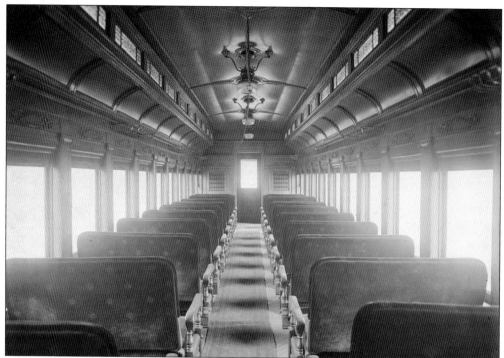

This photograph shows the interior of the seating section of the Pennsylvania Railroad's 4928. The seating was a traditional bench, but the car had decorative lighting fixtures and beautifully carved wood panels above the windows. (Courtesy of the Library of Congress, Prints & Photographs Division, Harris & Ewing Collection.)

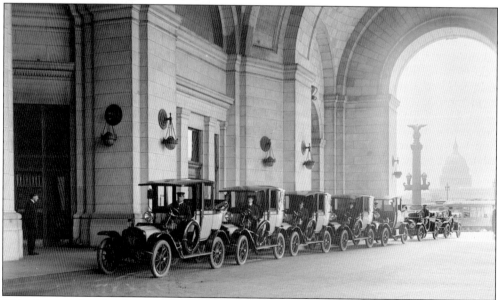

This photograph, taken between 1911 and 1920, shows a line of taxicabs parked in front of Union Station. Railroad travel was at its busiest during these years, and taxicabs queued up to transport passengers around the city. (Courtesy of the Library of Congress, Prints & Photographs Division, Harris & Ewing Collection.)

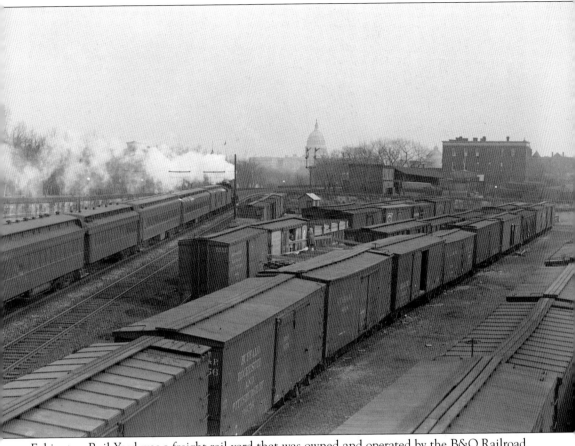

Eckington Rail Yard was a freight rail yard that was owned and operated by the B&O Railroad and located about one mile north of the US Capitol in northeast Washington. This photograph, taken in 1917, shows freight cars in the yard and a view of the Capitol in the distance. The Eckington neighborhood was a residential subdivision and also home to the Eckington and Soldiers' Home Railway Company, the first electric streetcar line in Washington, which provided rapid transportation across the city. The line began service in 1888 and was removed in the 1950s, when North Capitol Street was dug lower underneath New York Avenue to facilitate high-speed, high-volume traffic. Although the streetcars are no longer in operation, the neighboring Eckington Rail Yard still carries freight. It became a part of CSX Corporation in 1980. (Courtesy of the Library of Congress, Prints & Photographs Division, Harris & Ewing Collection.)

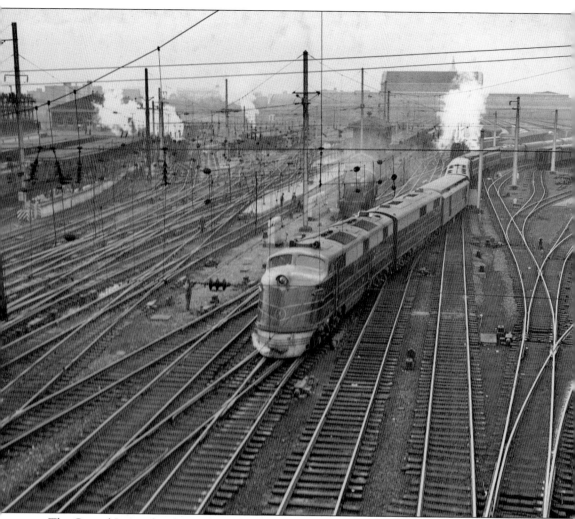

The Capitol Limited is shown in an elevated view as it enters the maze of tracks that crisscross Washington's terminal and starts the trip to New York. Union Station is dimly visible in the background. The Capitol Limited, with Pullman sleeping cars operated by the Baltimore & Ohio Railroad from 1923 to 1971, was designed to compete against the luxury trains of the rival Pennsylvania and New York Central Railroads. During the day, the upper berth was folded up like a modern airliner's overhead luggage compartment. At night, it was pulled down, and the two facing seats below it folded over to provide sleeping quarters for the night. Today, the Capitol Limited is the name of Amtrak's daily service between Washington, DC, and Chicago. Coach seating and sleeper service are available on the current rail line. (Courtesy of the National Archives.)

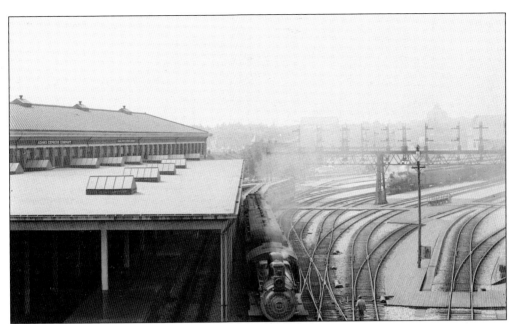

In the 1920s, trains were the dominant mode of mass transportation, providing comfortable, reliable service to millions of Americans. This photograph shows several trains moving through the Washington, DC, yard during this busy time period. Passenger rail travel reached its all-time high, with 1.2 million passengers boarding 9,000 intercity trains each day. (Library of Congress, Prints & Photographs Division, Detroit Publishing Company Collection.)

The *Columbian* was operated by the Baltimore & Ohio Railroad. It was the first air-conditioned passenger train in North America and began running in 1931. Reclining "Sleepy Hollow" seats provided comfortable overnight travel. The backs of the seats adjusted to nine different reclining positions. The train traveled between Jersey City, New Jersey, and Washington, DC. (Courtesy of the National Archives.)

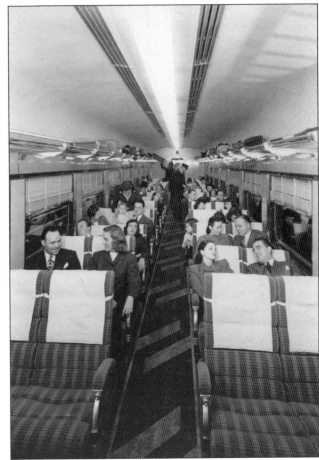

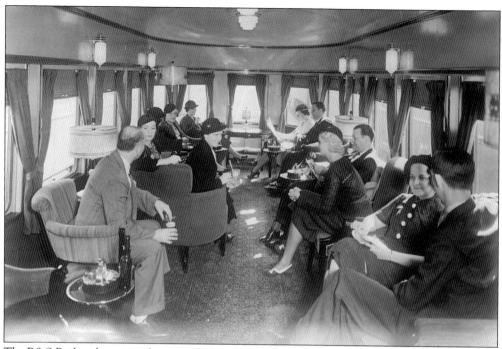

The B&O Railroad continued to upgrade the interior of its trains to provide better service and attract more customers. This photograph shows passengers in the first-class section, which was set up like a lounge with comfortable chairs and panoramic views. (Courtesy of the National Archives.)

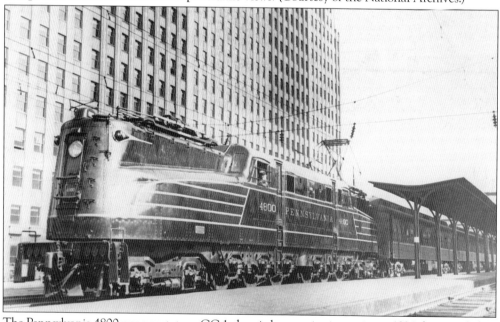

The Pennsylvania 4800 was a prototype GG-1 electric locomotive in service in 1934 that traveled 90 miles per hour on its route from New York to Philadelphia, Baltimore and Washington. In 1935, it made a round trip from D.C. to Philadelphia and, on its return trip, set a speed record by arriving back in D.C. 1 hour and 50 minutes after its departure from Philadelphia. Today 4800 sits is on display at the Railroad Museum of Pennsylvania in Strasburg, Pennsylvania. (Courtesy National Archives)

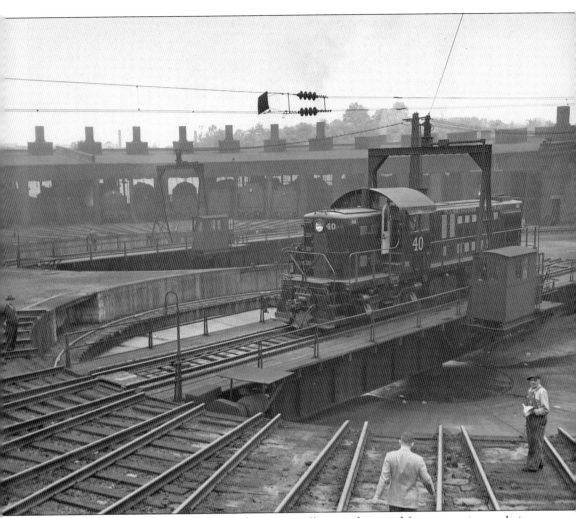

Steam locomotives used a railway turntable to turn rolling stock around for return trips, as their controls were often not configured to run in reverse. Turntables could be constructed to span anywhere from six to 120 feet, depending on the railroad's needs. This photograph shows an engine on the turntable at the Washington Terminal. The Washington Terminal Company owned and operated Union Station and about five miles of track in the Washington area, providing switching services for passenger trains. The Washington Terminal Company was a corporation created in 1901 to provide support to railroads using Union Station. It was jointly owned by the Baltimore & Ohio Railroad and the Philadelphia, Baltimore, and Washington Railroad. The terminal company's operations were taken over by Amtrak in 1981. (Courtesy of the Star Collection, DC Public Library, © *Washington Post*.)

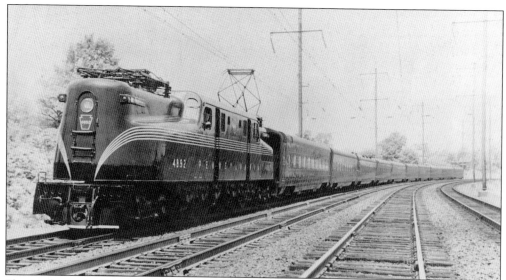

Shown above, the Pennsylvania 4892 was an electric locomotive that operated in the 1940s. The Pennsylvania Railroad (PRR) was the largest railroad by traffic and revenue in the U.S. throughout the first two-thirds of the twentieth century. In 1885, the PRR began passenger train service from New York City to Washington. In 1968, PRR merged with New York Central to form the Penn Central. (Courtesy of the *New York Times*.)

The 1947–1949 *Freedom Train* was a special exhibit train that toured the United States in the years following World War II. The train carried the original versions of the US Constitution, Declaration of Independence, and Bill of Rights on its tour of more than 300 cities in all 48 states. (Courtesy of the National Archives.)

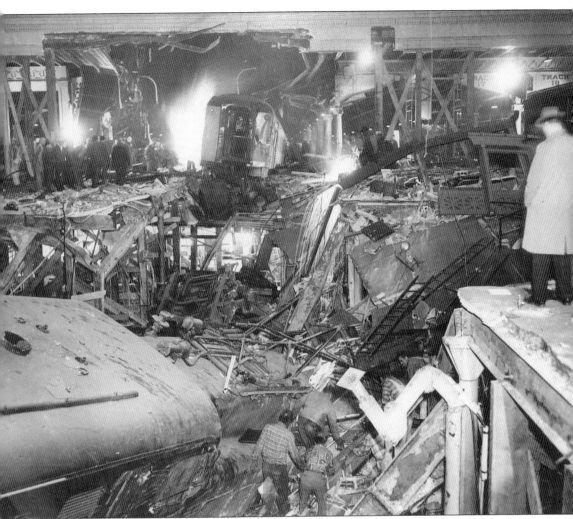

A train filled with passengers crashed into Washington's Union Station a few days before the presidential inauguration of Dwight D. Eisenhower. On January 15, 1953, a Pennsylvania Railroad train departed from Boston packed with passengers going to Washington, DC. The 16-car train lost control and crashed through steel and concrete barriers, plunging into the terminal basement at Washington's Union Station. An estimated 400 passengers were onboard at the time; fortunately, no one was killed, although 51 passengers were treated for injuries. It was later determined that the train's air brakes and emergency safety devices failed. The crash caused the collapse of Union Station's concourse flooring and demolished the stationmaster's office and the newsstand in the middle of the concourse. The accident eventually became the inspiration for the ending of the 1976 film *Silver Streak*. (Courtesy of the Star Collection, DC Public Library, © *Washington Post*.)

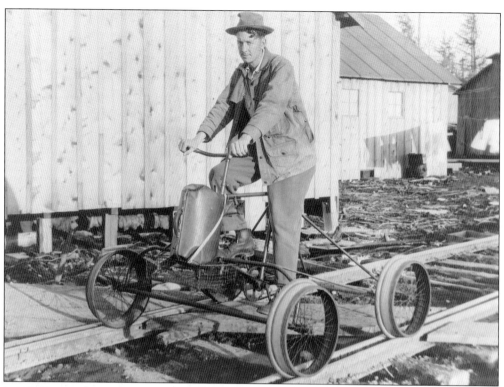

Tired of walking to town, an unidentified Washington man turned his bike and four papier-mâché wheels into a pedal-locomotive, creating an early commuter-rail vehicle in the form of a one-man train. This photograph was taken prior to 1950, before safety regulations were enforced. (Courtesy of the Library of Congress, Prints & Photographs Division.)

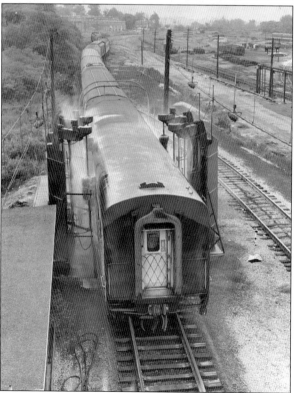

Trains need to be cleaned and serviced. Cleaning means a regular exterior water wash and interior sweeping and dusting or vacuuming. The Pennsylvania Railroad called this 1964 automatic car washer the "Eager Beaver washer." Today's washers are high-tech and work like a modern car wash, cleaning the train automatically as it is driven through. (Courtesy of the Star Collection, DC Public Library, © *Washington Post*.)

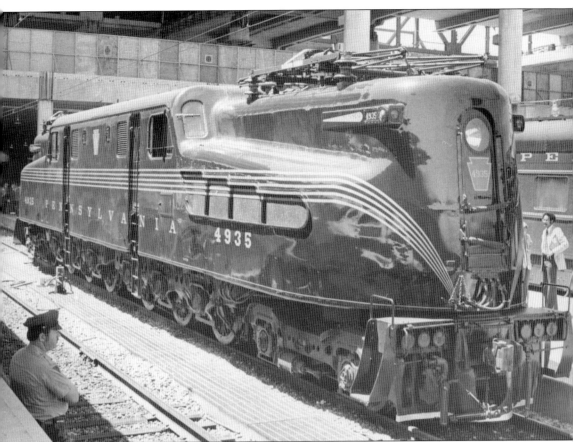

The Pennsylvania 4935, nicknamed "Blackjack," was a GG1 electric locomotive that traveled between New York City, Washington, DC, and Harrisburg, Pennsylvania. It was introduced as part of the Pennsylvania Railroad's massive 1930s project to electrify the line, move more trains with more cars, and accelerate faster. The design was called GG1 because the wheel arrangement was the same as two Class G (4-6-0) steam locomotives coupled back to back. The GG1 series had large steel frames and could carry heavy loads. In 1968, when the Pennsylvania Railroad merged with the New York Central Railroad to form the Penn Central Transportation Company, the 4935 continued in service. In 1977, the 4935 was restored and dedicated at a grand ceremony in Washington's Union Station. In 1983, it was donated to the Railroad Museum of Pennsylvania in Strasburg, where it resides today. (Courtesy of the Star Collection, DC Public Library, © *Washington Post*.)

This is a 1992 aerial view looking southeast towards Washington at the Long Bridge (far right), the Charles R. Fenwick Bridge (center), and the Arland D. Williams Jr. Memorial Bridge (left). These spans plus another two automobile bridges make up what is today known as the Fourteenth Street Bridge. The Long Bridge, built in 1903 and rebuilt in 1943, carries CSX, Amtrak, and Virginia Railway Express rail traffic over the Potomac River. The Charles R. Fenwick Bridge was built in 1983 to transport passengers on the Metrorail Yellow Line. The Arland D. Williams Jr. Memorial Bridge is the northbound automobile bridge. It opened in 1950 and was renamed in 1983 in memory of a passenger on Air Florida Flight 90 who died while saving others from the freezing water following the tragic airplane crash. (Courtesy of the Library of Congress, Prints & Photographs Division, HAER.)

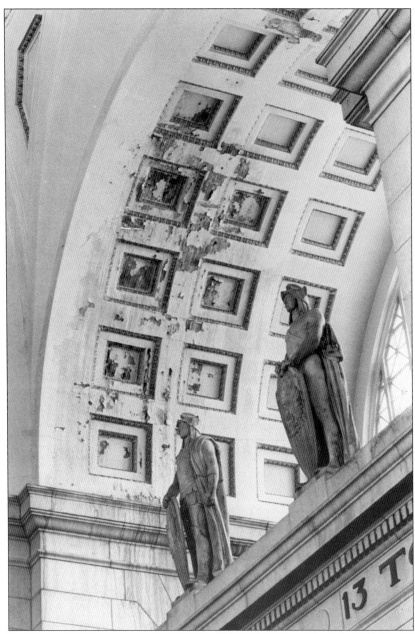

Until the 1950s, railroads were the only way to travel long distances relatively quickly. As airplanes, automobiles, and buses began competing with the country's railroads for long-distance travel, the railroads responded to the competition with new equipment. But as the number of passengers continued to drop, the rail companies had little incentive to make major capital investments to upgrade their facilities. During the 1960s, rail passenger service began to decline, and passenger facilities diminished across the country. Union Station began to age and show signs of physical deterioration. By the early 1970s, Washington's "Grand Terminal" was in danger of demolition. What was once the city's largest and most distinctive building would need millions of dollars to restore. This photograph shows damage to a decorative arched ceiling in the Main Hall at Union Station. (Courtesy of the Star Collection, DC Public Library, © *Washington Post*.)

Four

UNION STATION FACILITIES

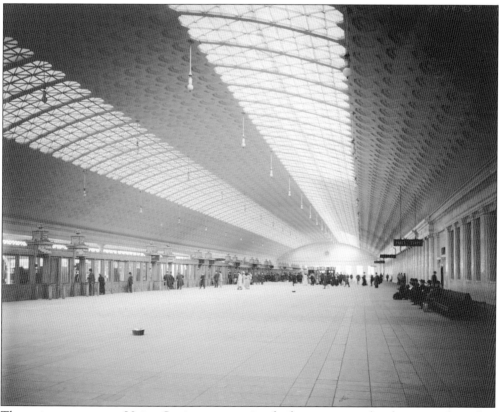

The train concourse at Union Station was massive, built to accommodate large crowds so they could move easily between the terminals. The vaulted ceilings were creatively designed combining marble and glass, which allowed natural light into the space and provided a comfortable passageway for travelers. (Courtesy of the Library of Congress, Prints & Photographs Division, Detroit Publishing Company Collection.)

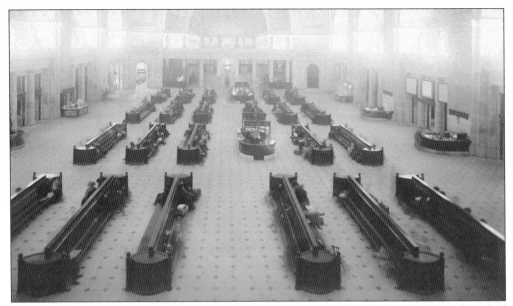

The general waiting room was 130 feet by 220 feet and was covered by a 90-foot-high barrel-vaulted ceiling. It was well lighted by semicircular windows that were 75 feet in diameter at each end and five semicircular windows that were 30 feet in diameter on each side. This photograph shows the arrangement of settees, telegraph booths, and the newsstand–ticket lobby in the distance. (Courtesy of the Library of Congress, Prints & Photographs Division.)

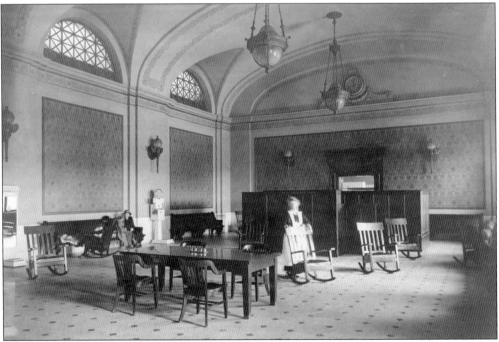

This photograph shows the Ladies Waiting Room at Union Station between 1910 and 1920. During this time period, there were separate waiting facilities as well as a general waiting area designed for travelers with lengthy layovers. This room was dramatically styled with high, vaulted ceilings and plenty of open space. (Courtesy of the Library of Congress, Prints & Photographs Division.)

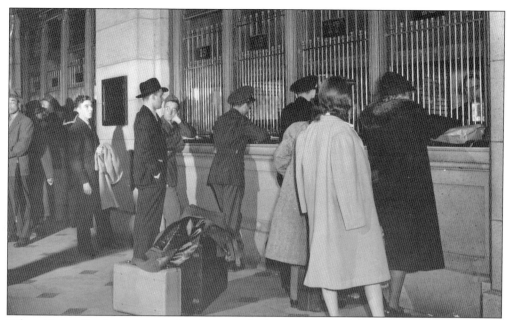

When Union Station was completed, it was the largest passenger terminal in the world. The Pennsylvania Railroad was the largest railroad company in America, controlling the routes from Washington, DC, to New York and from Philadelphia to Chicago. Union Station was a very busy facility, with tens of thousands of passengers traveling through each day. (Courtesy of the Library of Congress, Prints & Photographs Division.)

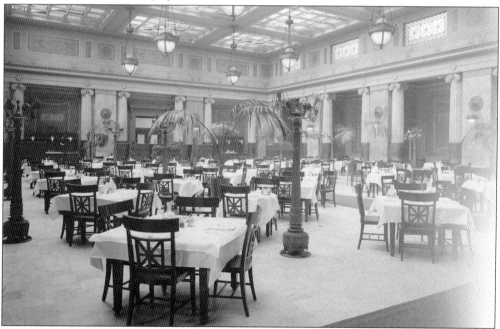

This photograph shows the dining room at Union Station during the 1920s. The building has at various times housed a wide range of amenities, including first-class restaurants, a bowling alley, movie theaters, a hotel, YMCA, Turkish baths, a police station, an icehouse, a nursery, a liquor store, and much more. (Courtesy of the Library of Congress, Prints & Photographs Division.)

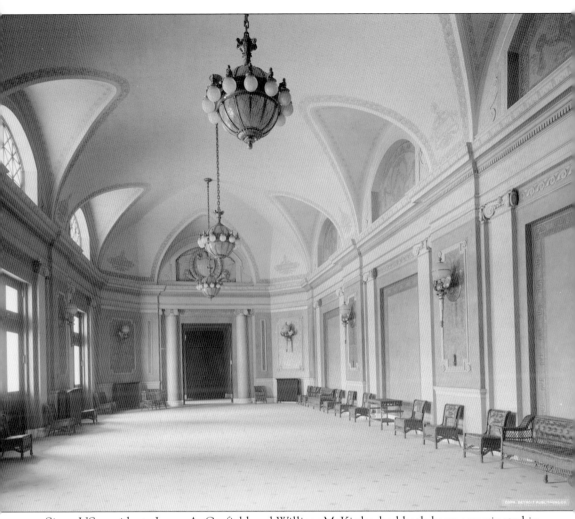

Since US presidents James A. Garfield and William McKinley had both been assassinated in railroad stations, Union Station executives authorized a secure presidential suite away from the crowds with its own entrance. The three-room suite had many of the same design elements as the rest of the building, with the addition of presidential seals, stenciled foliage, marble, and granite. In 1988, it was restored to its original design with walls that are painted to resemble the faux leather and faux mahogany in the original construction. The suite also features elaborate polychromatic stencil designs and replicas of the presidential eagle. Over the years, many famous dignitaries were officially greeted in these rooms, including King George VI and Queen Elizabeth of England, King Albert of the Belgians, King Prajadhipok of Siam, Queen Marie of Romania, and King Hassan II of Morocco. (Courtesy of the Library of Congress, Prints & Photographs Division.)

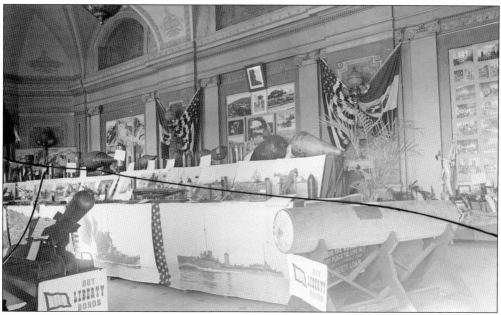

An Italian display was set up in the Presidential Suite between 1910 and 1920. The space has been used for a variety of special functions over the years. In 1938, it was refurbished for a visit from Britain's King George VI and Queen Elizabeth. During World War II, the suite was used by thousands of servicemen who were passing through the city. (Courtesy of the Library of Congress, Prints & Photographs Division.)

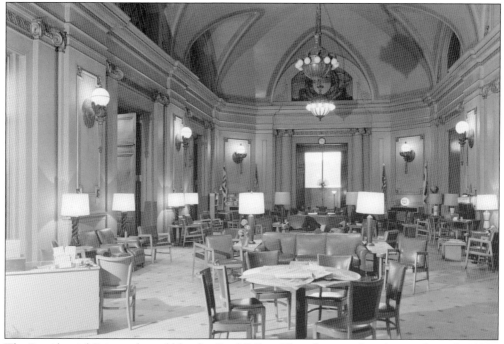

The Presidential Suite is shaped like the Oval Office. This photograph, taken in the early 1970s, shows the Presidential Waiting Room, furnished simply with tables and chairs and comfortable lounging facilities. (Courtesy of the Library of Congress, Prints & Photographs Division.)

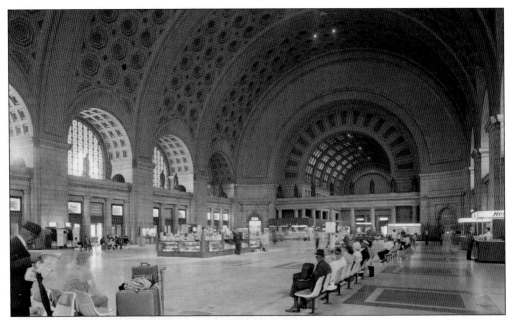

The main concourse with access to platforms is 760 feet long and trimmed with white enamel brick and terra-cotta, classical detailing, and sculptures throughout. In an alcove just east of the main doors was a drugstore and a soda fountain featuring marble, onyx, brass, and silver. In the west alcove were mahogany-and-glass telephone booths. There were a newsstand and a florist and two stands for sending telegrams. (Courtesy of the Library of Congress, Prints & Photographs Division, HABS.)

As the center of transportation for the nation's capital, Union Station has always been a busy destination with thousands of daily visitors from all walks of life. Politicians, foreign diplomats, military personnel, and international celebrities have visited Washington's train station. This photograph shows passengers and an information clerk searching for prepurchased tickets at the ticket information booth. (Courtesy of the Library of Congress Prints and Photographs Division.)

The entrance to the train concourse from the waiting room looks much the same today. Roman legionnaires line the ledge of the balcony. Union Station had a wide range of amenities including a bowling alley, mortuary, bakery, butchery, YMCA, hotel, icehouse, resident doctor, liquor store, Turkish baths, first-class restaurant, basketball court, swimming pool, nursery, police station, and silver-monogramming shop. (Courtesy of the Library of Congress, Prints & Photographs Division, HABS.)

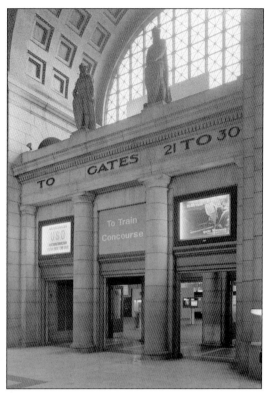

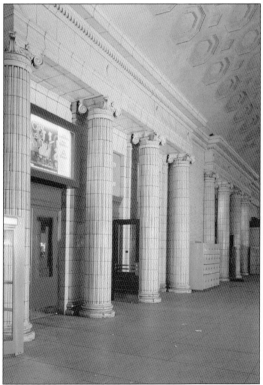

This 1974 photograph shows the interior detail of the entrance to the Waiting Room from the train concourse. The doorway was designed to provide a grand entrance. Here, the paint is starting to chip on the pillars, and the facility is aging. (Courtesy of the Library of Congress, Prints & Photographs Division, HABS.)

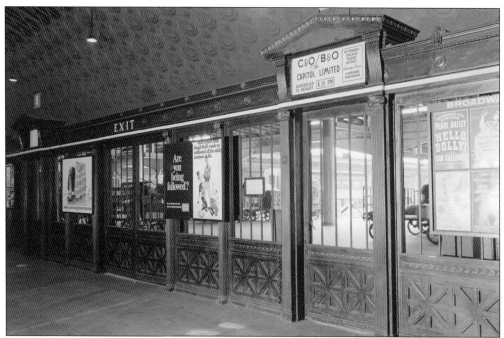

The train gates at Union Station served as a divider between the waiting areas and the train platforms. Advertising signs and billboards were used to attract the attention of the public while traveling in and out of the station. (Above, courtesy of the Library of Congress, Prints & Photographs Division, HABS; below, courtesy of the Commission of Fine Arts.)

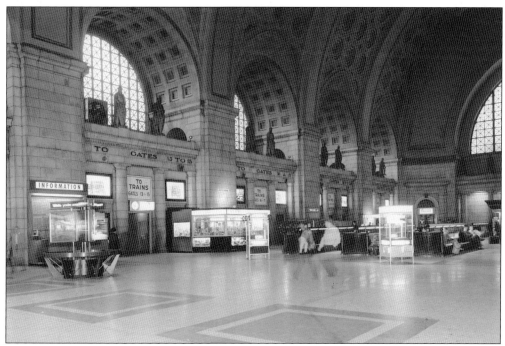

When Union Station opened in 1907, the 97,500-square-foot concourse was said to be the largest room in the world. Vendors set up newsstands and snack booths to provide conveniences to the travelers. The shops and services were provided by many local individuals, and the new station offered a great opportunity for small businesses. (Courtesy of the Commission of Fine Arts.)

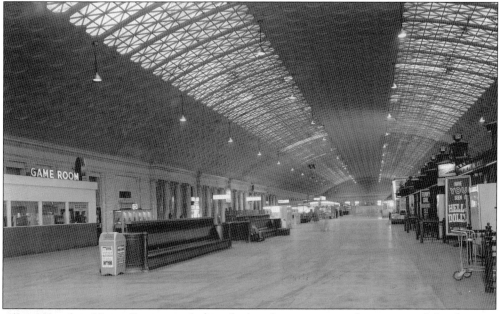

All woodwork in Union Station, including the booths, counters, and seats, was solid mahogany. The station had plenty of open space and very high ceilings. In this photograph, a game room, telephone booths, and many advertising posters lining the entrance to train gates can be seen. (Courtesy of the Commission of Fine Arts.)

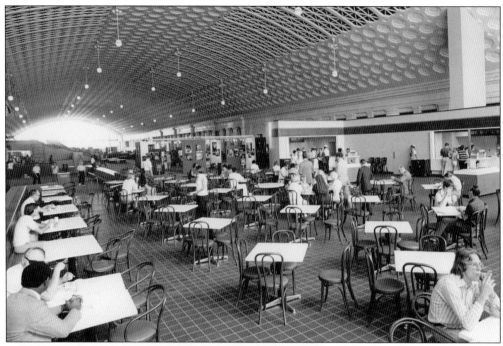

The dining room shown in this photograph, taken in the early 1970s, was very spacious in appearance, with a floor area of 6,500 square feet. More than 1,000 people could be accommodated at once. (Courtesy of the National Park Service.)

Travelers shopped for patriotic souvenirs or travel keepsakes as they passed through Union Station on their way out of Washington. Flags, postcards, and photographs are still popular souvenirs today. (Courtesy of the Library of Congress, Prints & Photographs Division.)

Five

EARLY UNION
STATION EVENTS

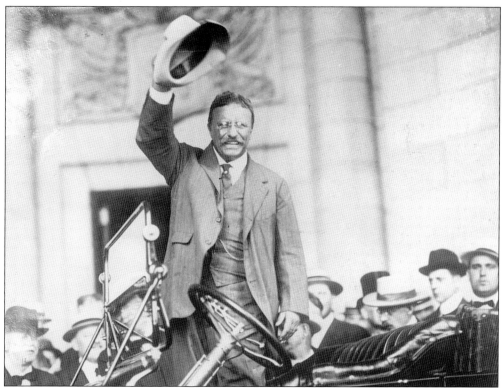

In 1903, Theodore "Teddy" Roosevelt, the 26th president of the United States (1901–1909), signed the act that paved the way for the construction of Union Station. He enjoyed the revelry of the new railroad depot. In this photograph, Roosevelt tips his hat to the crowd at Union Station. He was a charismatic president who was responsible for passing the Hepburn Act, which increased the Interstate Commerce Commission's role in the railroad industry, and the Mann-Elkins Act, which strengthened government regulation of railroads. (Courtesy of the Library of Congress, Prints & Photographs Division.)

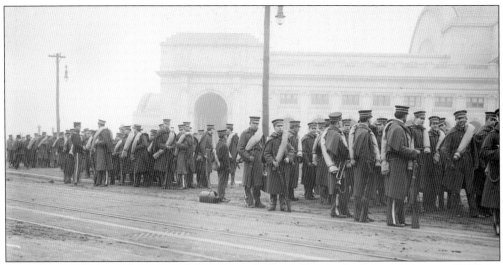

This photograph shows the National Guard outside Union Station for the inauguration of William Howard Taft, the 27th president of the United States. On March 4, 1909, Taft's inauguration was held indoors, in the Senate chamber, due to snowfall, drifting snow, and strong winds. Union Station has served as the capital's transportation terminal for 25 presidential inaugurations. (Courtesy of the Library of Congress, Prints & Photographs Division.)

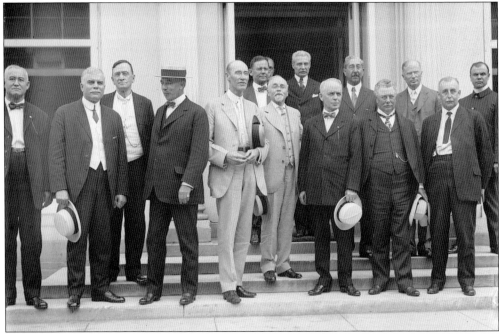

The heads of the railroad companies met regularly to discuss management issues. In this photograph, they pose at the White House in 1912. Pictured from left to right starting at far left are W.G. Lee, president of the Board of Railway Trainmen; Warren B. Stone, president of the Board of Locomotive Engineers; Herman W. Wills, of the Washington Republic Labor Organization; Alfred H. Smith, vice president of the New York Central Railway; and A.B. Garretson, president of the Order of Railway Conductors. (Courtesy of the Library of Congress, Prints & Photographs Division, Harris & Ewing Collection.)

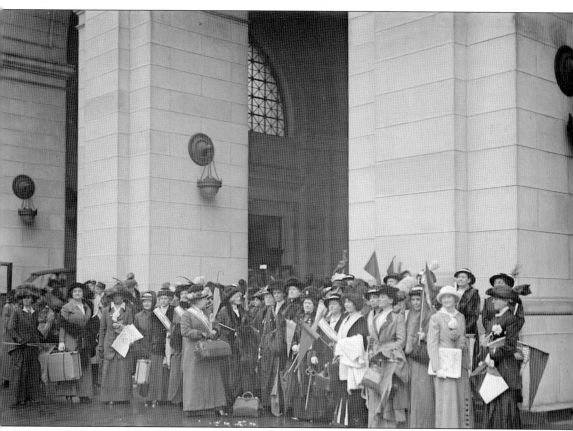

This photograph shows a large crowd of women gathered in front of Union Station for the National American Woman Suffrage Association Parade, which took place on March 3, 1913. Thousands of women traveled from across the country to participate in the event, held the day before Woodrow Wilson's first presidential inauguration. The parade was organized to bring attention to a federal suffrage amendment seeking to gain women's rights and the right to vote. Suffragists organized marches and parades as forms of active protest. Groups participated in huge pickets, including a daily picket of the White House. In 1920, the 19th Amendment was passed by the House and Senate and ratified by the states, giving women the right to vote in all US elections. (Courtesy of the Library of Congress, Prints & Photographs Division, Harris & Ewing Collection.)

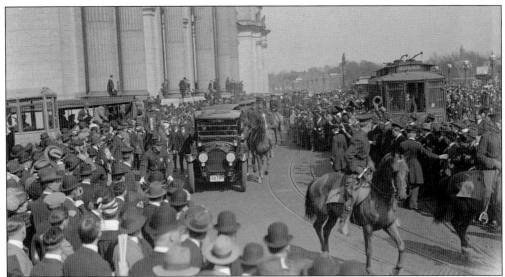

In April 1917, near the end of World War I, a massive crowd gathered in front of Union Station to welcome a British commission headed by Arthur J. Balfour, minister of foreign affairs, to Washington. The British were allies to America, and their leaders met with President Wilson, Vice President Marshall, and Secretary of State Lansing to discuss their war policies. Later that year, the United States declared war on Germany. (Courtesy of the Library of Congress, Prints & Photographs Division.)

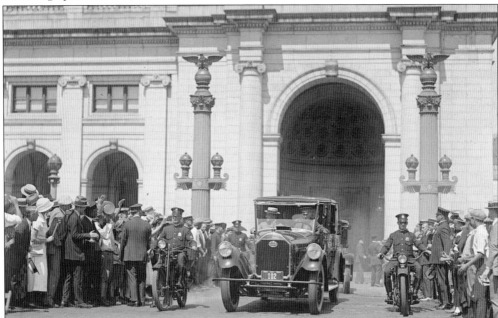

In its heyday, Union Station became a ceremonial destination for residents and visitors to welcome political figures and foreign dignitaries. President Wilson invited Edward, Prince of Wales, to visit Washington in the autumn of 1919. The prince was photographed at Union Station on his arrival in Washington. During his trip, he visited the White House, the American Red Cross, the French Embassy, and Walter Reed Army Hospital. (Courtesy of the Library of Congress, Prints & Photographs Division.)

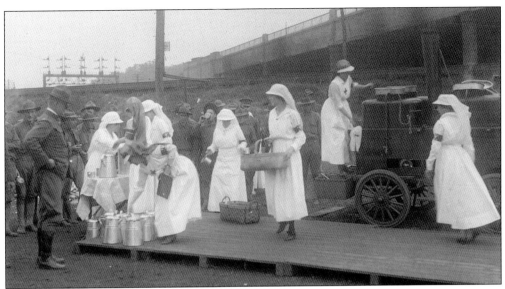

Clara Barton founded the American Red Cross in Washington, DC, on May 21, 1881. The organization was established to provide domestic and overseas disaster relief and to serve as a medium of communication between members of the American armed forces and their families. Prior to World War I, the Red Cross introduced its first aid, water safety, and public health nursing programs. With the outbreak of war, the number of local chapters expanded from 107 in 1914 to 3,864 in 1918. The Red Cross staffed hospitals and ambulance companies and recruited 20,000 registered nurses to serve the military. The photograph above shows nurses unloading supplies outside of Union Station. Red Cross volunteers shown below have gathered at Union Station for a meal. Washington's train station could accommodate 1,000 diners at one sitting. (Both, courtesy of the Library of Congress, Prints & Photographs Division.)

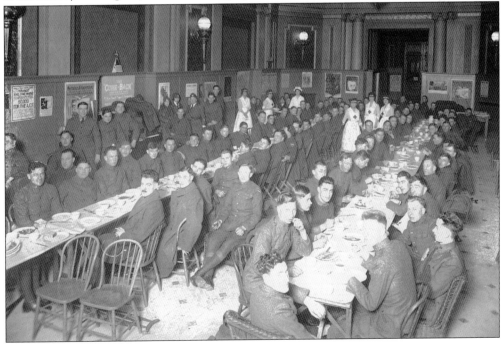

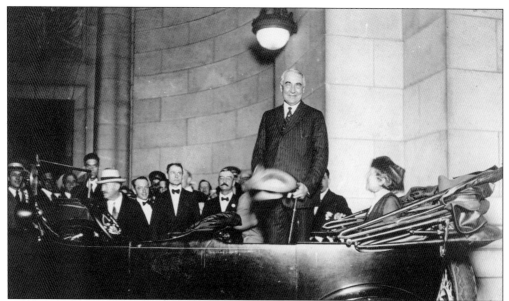

This photograph, taken around 1920, shows Sen. Warren G. Harding standing in the back of a car with his wife, Florence, seated in the backseat and a crowd in the background at Union Station. Harding became the 29th president of the United States in 1921. He died while in office from a heart attack in 1923. (Courtesy of the Library of Congress, Prints & Photographs Division.)

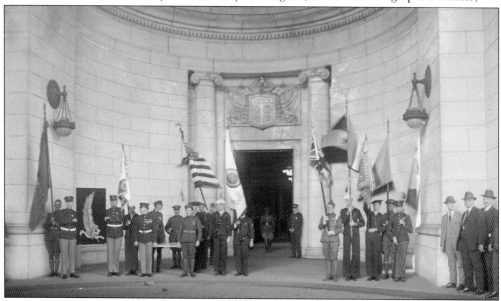

The American Legion was chartered by Congress in 1919 as a patriotic organization providing service to veterans, members, and communities throughout the world. The American Legion's efforts resulted in the creation of the Veterans Bureau (now the Veterans Administration). This photograph, taken in 1922, shows members of the American Legion holding a flag ceremony in honor of veterans at Union Station. Over the years, the American Legion has founded many programs for children and youth and has lobbied for adequate funding to cover the costs of medical, disability, education, and other veterans benefits. (Courtesy of the Library of Congress, Prints & Photographs Division.)

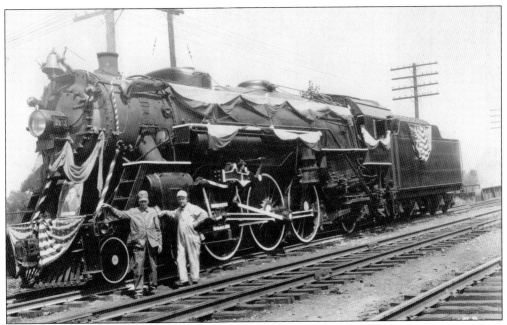

The Erie Railroad sent a locomotive to Washington on August 8, 1923, for the funeral of Pres. Warren G. Harding. No. 2933 was draped with patriotic fabric in commemoration of the sad occasion. (Courtesy of the Library of Congress, Prints & Photographs Division.)

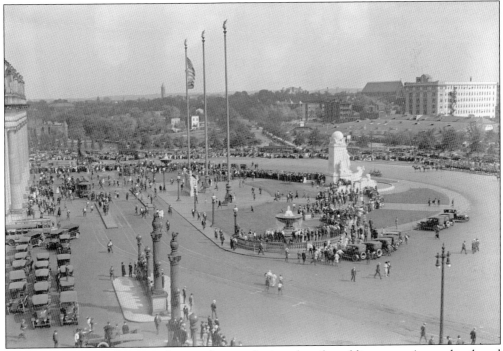

The Union Station Plaza was often used as a gathering place for public events. A crowd gathered to welcome Gen. John J. Pershing upon his return from France in 1923. He was the leader of the American Expeditionary Forces sent to Europe in World War I. (Courtesy of the Library of Congress, Prints & Photographs Division.)

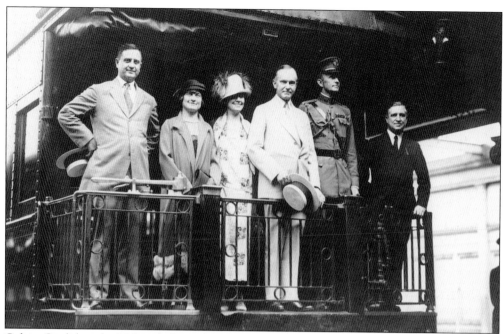

Calvin Coolidge, the 30th president of the United States (1923–1929), and First Lady Grace (in white hat) stand on the rear car of a train in 1928. Coolidge was president during the Roaring Twenties. (Courtesy of the Library of Congress, Prints & Photographs Division.)

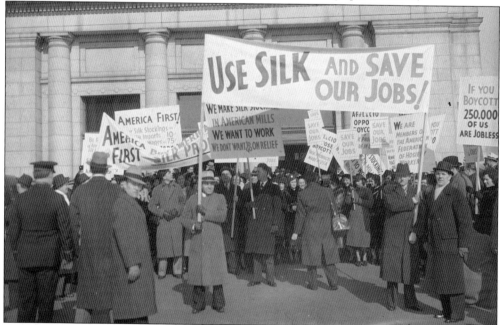

On January 28, 1938, members of the American Federation of Hosiery Workers arrived at Union Station and staged a parade to the White House as a protest against the boycott of Japanese silk. A reported 300 marchers carried banners exhorting women to continue to wear silk hose and save the jobs of thousands of hosiery workers. (Courtesy of the Library of Congress, Prints & Photographs Division, Harris & Ewing Collection.)

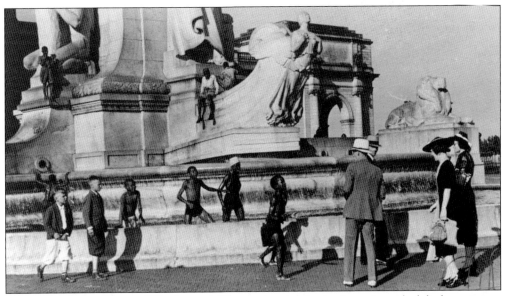

This photograph, taken in 1938, shows children swimming in the fountain and adults lounging on the Christopher Columbus Memorial in front of Union Station. Washington is known for its hot and humid summers. Especially in the years before air-conditioning, children took advantage of the water in the city's fountains to cool off on hot days. This is probably not what the architects and sculptors had in mind when they designed the memorials. Today, the DC Police would probably chase them off for disrespecting public property. (Courtesy of the Library of Congress, Prints & Photographs Division, Farm Security Administration–Office of War Information [FSA-OWI] Collection.)

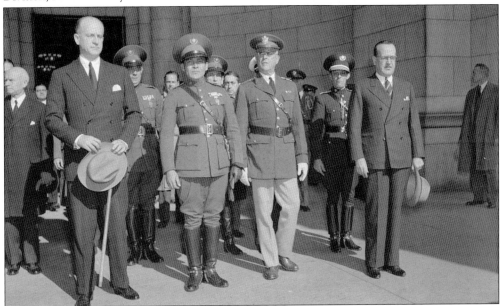

On November 10, 1938, Col. Fulgencio Batista, Cuba's dictator, arrived in Washington. He was met at Union Station by Gen. Malin Craig, chief of staff of the US Army, and Undersecretary of State Sumner Welles, as well as 100 Cubans who bowed to the colonel as he passed by. In this photograph, from left to right, are Welles, Batista, Craig, and Cuban ambassador to the United States Dr. Pedro Fraga. (Courtesy of Library of Congress, Harris & Ewing Collection.)

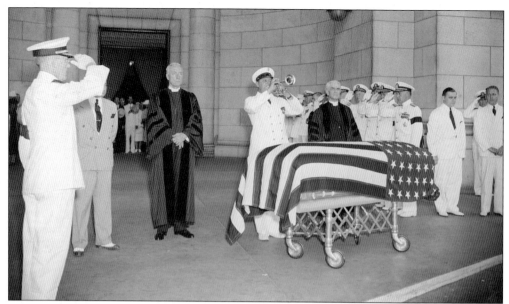

Last honors were paid to Navy Secretary Claude A. Swanson at Union Station on July 10, 1939. While the Senate chaplain, the Reverend Ze Barney Phillips, stood on the bugler's right and the Reverend James Shera Montgomery, chaplain of the House, stood on the left, a navy bugler blew taps over the casket when the body arrived on a gun caisson at Union Station for entrainment to Richmond for the funeral. (Courtesy of the Library of Congress, Prints & Photographs Division, Harris & Ewing Collection.)

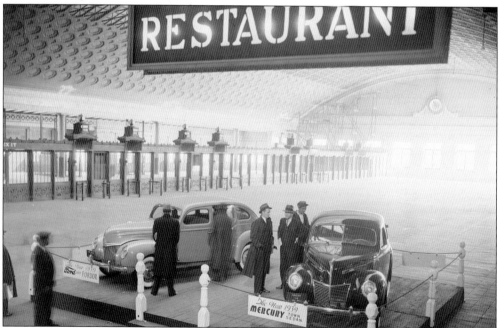

Since many people passed through Union Station each day, it became a great place for businesses to show off new products. In this photograph, the Ford Motor Company displays a new 1939 Mercury Town Sedan at the railroad terminal. (Courtesy of the Library of Congress, Prints & Photographs Division.)

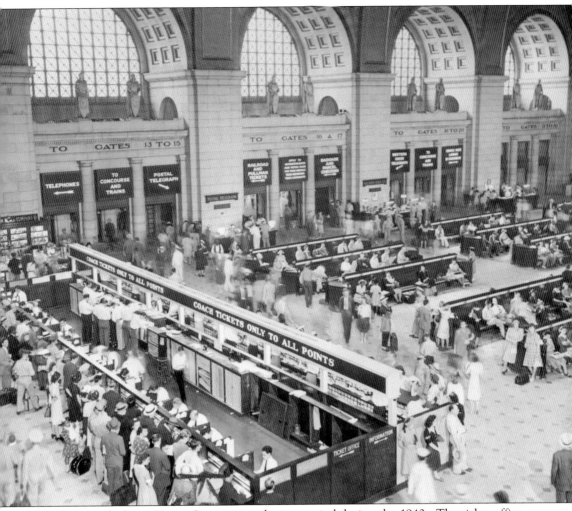

This photograph shows Union Station at its busiest period during the 1940s. The ticket office needed dozens of agents to help the more than 100,000 passengers who came through the gates every day. Information clerks answered an average of 80,000 questions daily. Travelers patiently stood in lines, and many waited on benches in the main terminal. Separate ticket counters were provided for coach and first-class travelers, similar to the way airline ticket counters are arranged at modern airports today. At its busiest periods, the station employed as many as 5,000 people and operated relatively efficiently. The signs in the station were clearly marked to help passengers find their way. The postal telegraph and the Western Union desks were busy with servicemen sending messages home to their loved ones. (Courtesy of the Star Collection, DC Public Library, © *Washington Post*.)

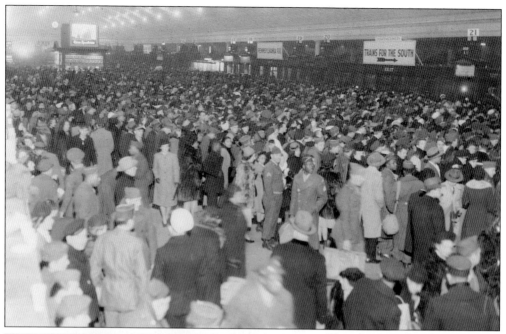

This photograph, taken on December 22, 1945, shows a huge crowd heading home for the Christmas holidays. Rail travel was at its busiest period following the end of World War II, and travelers had to wait a long time to get on the trains to leave Union Station. (Courtesy of the Washingtoniana Division, DC Public Library.)

At the end of World War II, Union Station hosted an exhibit on Russia so that visitors could learn about the nation and its role in the conflict. Russia invaded Berlin in 1945 and came out of the war militarily victorious but economically and structurally devastated. America was supportive of Russia at this time, prior to the Cold War that erupted in 1947. (Courtesy of the Star Collection, DC Public Library, © *Washington Post*.)

Six

REDEVELOPING
UNION STATION

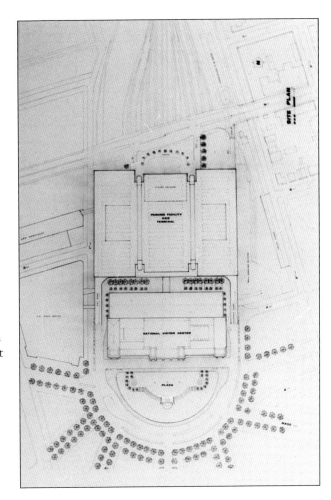

By the 1960s, train travel was on the decline, and Union Station had fallen into disrepair. Officials began to consider alternative uses for the building, such as turning it into the National Visitor Center, a transportation museum, an ice-skating rink, or a convention hall. In 1967, Congress agreed to restore the building as a visitor center. This drawing shows a site plan of Union Station created at that time. (Courtesy of the Commission of Fine Arts.)

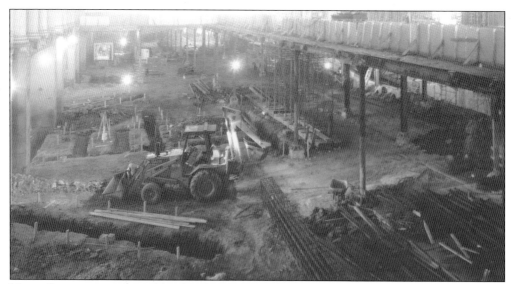

Union Station, as a national landmark, was virtually impossible to tear down. Railroad owners offered the building to the federal government, which agreed to an estimated cost of $16 million to convert the facility into the National Visitor Center, an information center for tourists visiting Washington, DC. The plan was to redesign the station in time for the nation's celebration of its bicentennial in 1976 and to build a parking garage and a smaller transportation depot for continued rail service. The construction included digging out a basement level beneath the floor of the Main Hall to display a multiscreen slide-show presentation. The train station and operations were moved to the rear of the old terminal. At the same time, the Washington Metrorail was under construction and was built underground with access provided from the street to the rail platform. Both of these photographs show construction crews working on the basement level of Union Station. (Above, courtesy of the Library of Congress, Prints & Photographs Division; below, courtesy of the National Park Service.)

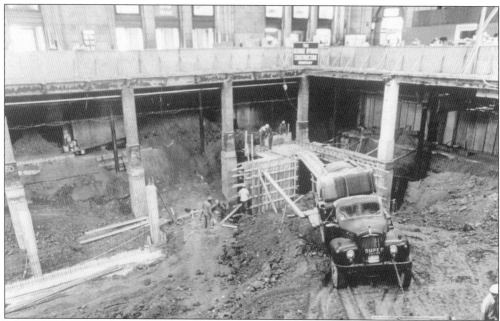

Also during this same time period, in October 1970, in an attempt to revive passenger rail service, Congress passed the Rail Passenger Service Act, which created Amtrak, a private company, to manage a nationwide rail system dedicated to modern and efficient passenger service. Amtrak provides train transportation between major cities as well as commuter service and delivery of mail and express freight. (Courtesy of Amtrak.)

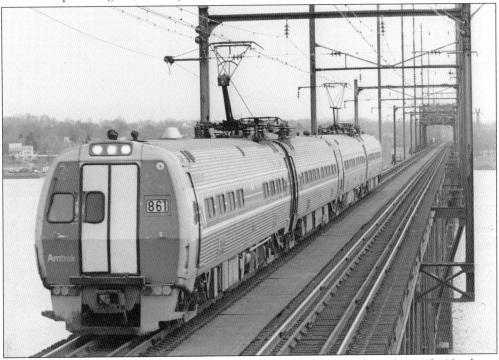

Amtrak's 1976 electric locomotives presented a new look in train travel to riders in the Northeast Corridor. The *Metroliner* high-speed train operated between Washington and New York as an electric, self-propelled train offering premium service. It was the only train traveling over 100 miles per hour in the United States at the time. (Courtesy of Amtrak.)

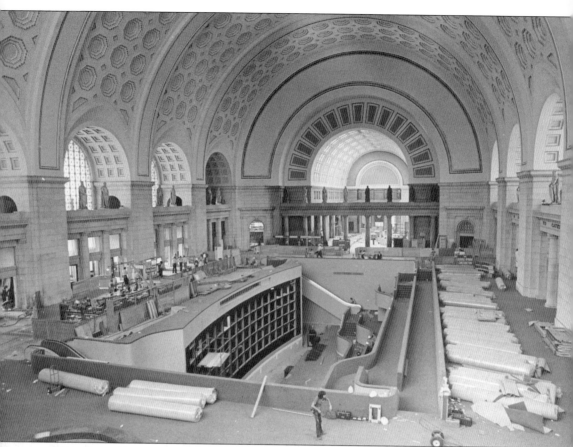

When Union Station was remodeled in 1976, it was designed as a destination where a visitor could gather information about Washington's monuments, museums, and government buildings. The floor of the main hall was torn out to create a lower level to house an elaborate audiovisual experience. Remodeling such a massive building was a major undertaking and was grossly mismanaged, with contract disputes and jurisdiction battles among the railroads, architects, contractor, Congress, National Park Service, Federal Railroad Administration, and Departments of Interior and Transportation. Due to a lack of publicity and convenient parking, the National Visitor Center was a complete failure and an embarrassment to the city. It closed after just two years. Rain damage caused parts of the station roof to collapse, and the building remained closed for several years for safety reasons. Rail and Metro service continued to operate with separate passenger entrances during this period. Controversy continued among city officials over the future use of the historic structure. (Courtesy of the Star Collection, DC Public Library, © *Washington Post*.)

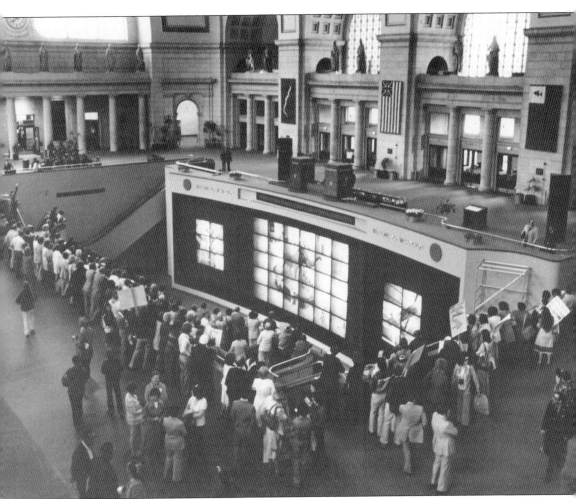

At the National Visitor Center's audiovisual experience, visitors viewed a nine-minute slide show about DC landmarks and learned about sightseeing in the nation's capital. This photograph shows visitors watching a film in the 8,000-square-foot sunken area of the Main Hall that was sarcastically referred to as "the Pit." The National Visitor Center was also remodeled to include two 175-seat movie theaters, a national bookstore, a hall of flags, and multilingual information booths. More than a decade later, when Union Station was eventually revitalized, the space where the audiovisual experience had resided was filled in and rebuilt to the same level as the rest of the Main Hall. It is now the location of the Center Café Restaurant, an elevated dining establishment that resides in the center of the Main Hall. (Courtesy of the National Park Service.)

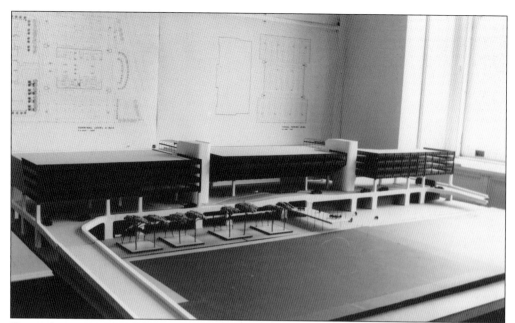

Original construction of the Union Station parking garage began with the intended completion at the same time as the National Visitor Center in 1975. The project was delayed for years by multimillion-dollar cost overruns, design conflicts, and bureaucratic battles. The garage was not completed until September 1988. This photograph shows a model for the parking garage. (Courtesy of the Commission of Fine Arts.)

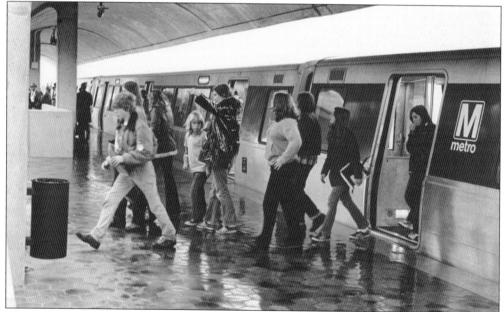

The Washington Metropolitan Transit Authority (WMATA) was created in 1967 to plan, develop, and operate a regional transportation system for the Washington metropolitan area. WMATA began building the rail system in 1969, acquired four regional bus systems in 1973, and began operating the first phase of Metrorail in 1976. (Courtesy of the Washington Metropolitan Transit Authority, photograph by Paul Myatt.)

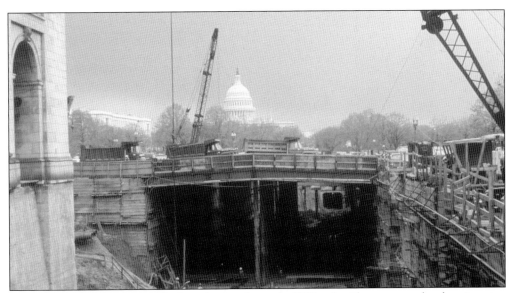

While train travel was on a decline during the early 1970s, the idea to turn the deteriorating station into transportation complex was beginning to take root. With its proximity to the Capitol and the east end of the National Mall, Union Station was an ideal location for a Metrorail stop. The station was one of the first completed. This photograph shows the construction of Metro at Union Station in 1976. The station is located in the center of the Red Line, which runs from Shady Grove (Gaithersburg) to Glenmont (Wheaton) in the Maryland suburbs. (Courtesy of the Washington Metropolitan Transit Authority.)

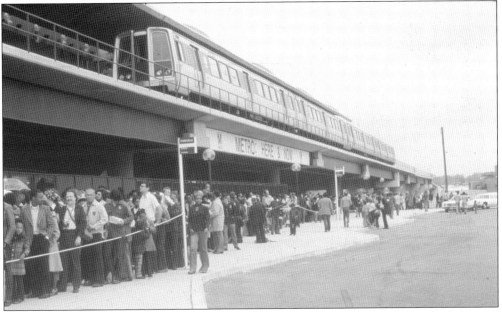

Washington Metrorail, a 106-mile rapid-transit system, was built in 1976 to provide alternative transportation to commuters and visitors from around the world. This photograph shows a line of passengers outside Metro on opening day on March 29, 1976. More than 51,000 persons rode free over the 4.2 miles of Metro's Phase 1. Five stations opened on the Red Line from Rhode Island Avenue to Farragut North. (Courtesy of the Washington Metropolitan Transit Authority.)

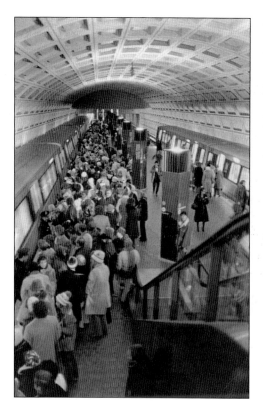

The Metrorail subway system serves the District of Columbia and its Maryland and Virginia suburbs. Today, Union Station is one of the busiest stations in the subway system. Since opening, the Metro system has grown to include five lines, 86 stations, and 106.3 miles of track. This photograph shows the Union Station Metrorail during rush hour. (Courtesy of the Washington Metropolitan Transit Authority, photograph by Paul Myatt.)

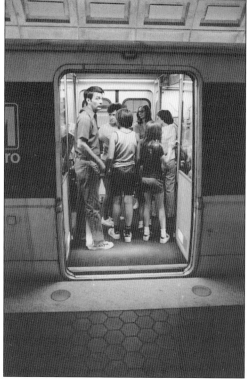

Metro is the second-busiest rapid transit system in the United States, after the New York City Subway. It is especially busy during rush hours, Monday through Friday, 6:00 a.m. to 9:00 a.m. and 3:00 p.m. to 7:00 p.m., and during popular events such as the National Cherry Blossom Festival, the Fourth of July, New Year's Eve, and any time that there is a political rally or public event drawing a large crowd. Riders often have to stand and sometimes even have to wait for the next train. (Courtesy of the Washington Metropolitan Transit Authority, photograph by Paul Myatt.)

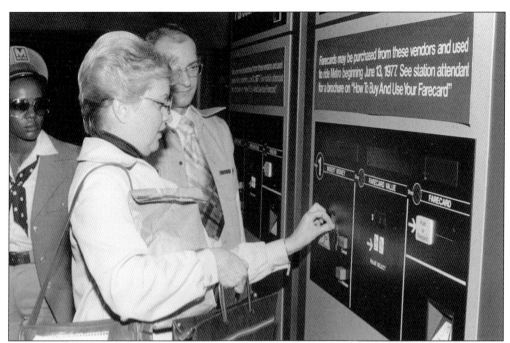

Metro fare cards are purchased primarily at vending machines in each station. Fares are based on the distance traveled and the time of day. Paper fare cards were used initially, but as technology evolved, regular Metrorail riders began using the SmarTrip® plastic card, a permanent, rechargeable fare card that works like a debit card. The fare card machines have always seemed to be a little confusing to use, especially for newcomers. (Courtesy of the Washington Metropolitan Transit Authority, photograph by Paul Myatt.)

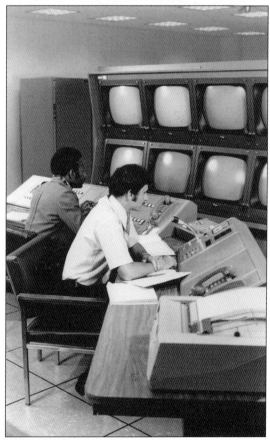

The first phase of Metrorail in 1976 operated just five stations and 4.5 miles of track. The region's rapid-transit system has expanded and today serves 86 stations with 106 miles of track. Passenger trains are controlled by an Automatic Train Control system that accelerates and brakes the trains automatically without operator intervention. Train operators open and close the doors, make station announcements, and supervise their trains. This photograph shows the Metro Control Room. (Courtesy of the Washington Metropolitan Transit Authority, photograph by Paul Myatt.)

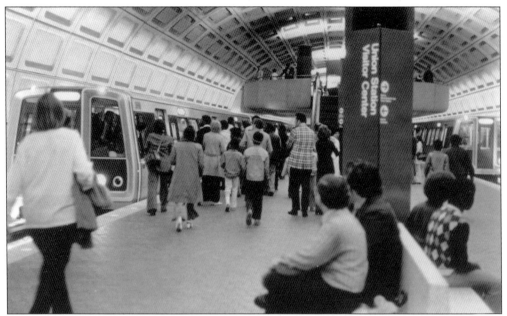

The Washington Metro was built with a modern design including grand, vaulted ceilings that glow with soft, indirect lighting. The construction of the Metro was unusual because while it was built in 1976, the rest of the nation was focusing on improving automobile transportation by building new roads and highways. (Courtesy of the Washington Metropolitan Transit Authority, photograph by Paul Myatt.)

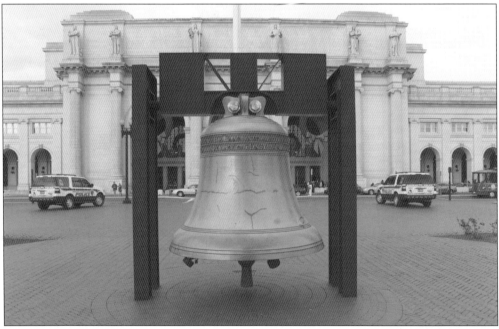

In 1981, the Freedom Bell, a replica of the Liberty Bell, was donated and installed in front of Union Station. It was cast for the nation's bicentennial by Whitechapel Bell Foundry in England, successor to the same firm that cast the Liberty Bell. The *American Freedom Train* carried the bell to all 48 contiguous states. It is nearly twice as large as the actual Liberty Bell. (Courtesy of Brian Cooper.)

The local rail passenger service now called MARC (Maryland Area Regional Commuter) has actually operated since the 1830s, originally as part of the B&O Railroad. In 1975, the Maryland Department of Transportation agreed to subsidize the rail operations and took over its management. MARC operates the fastest commuter trains in North America, using electric locomotives that race along at speeds of up to 125 miles per hour. The electric motors are maintained by Amtrak at its Ivy City engine terminal in Washington. CSX services and repairs the diesel fleet at the Riverside Shop in Baltimore. (Both, courtesy of Brian Cooper.)

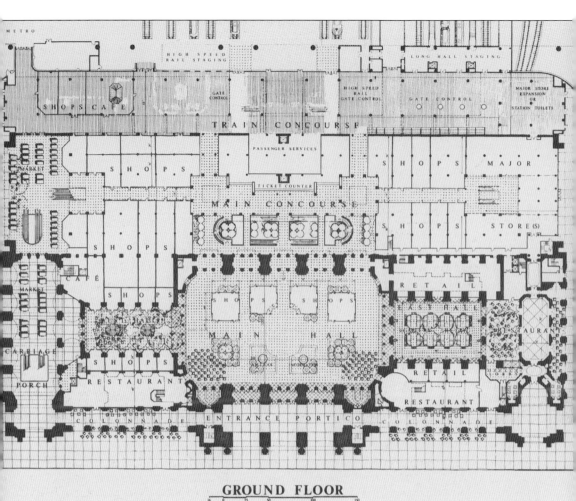

GROUND FLOOR

Following the National Visitor Center disaster, Union Station was uninhabitable and in danger of demolition. In 1981, legislation was enacted by Congress to preserve the building as a national treasure, to transform it into a transportation terminal, and to establish the building as a modern mixed-use commercial complex. The old station's usable space would double. The concourse where passengers caught the trains would be remodeled, with three levels of retail space featuring more than 100 shops, fast-food outlets, restaurants, and services such as shoe repair, car rental services, photograph processing, and currency exchange. This floor plan shows the design for the Main Hall, retail shops, and the train concourse on the ground floor. A ticket counter and passenger services would be set in the back of the building near the departure gates. Shops and restaurants were to be located in the central part of the building to create a premier shopping mall to appeal to both visitors and local residents. (Courtesy of the Commission of Fine Arts.)

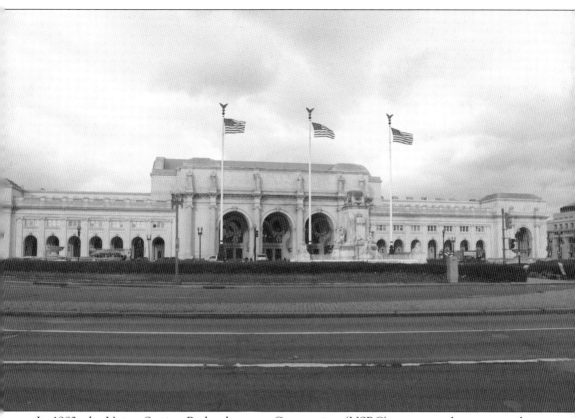

In 1982, the Union Station Redevelopment Corporation (USRC) was created to oversee the station's restoration as a modern intermodal transportation terminal and commercial center with a wide range of retail, dining, and entertainment options. Washington's Union Station was renovated at a cost of $160 million and reopened in 1988. It was the largest and most complex restoration project ever attempted in the United States. The remodeled station was designed by Benjamin Thompson & Associates, an architectural firm based in Cambridge, Massachusetts, that also developed Boston's Faneuil Hall Marketplace and Baltimore's Harborplace. The renovation was successful and brought the historic building back to its former glory as a significant monumental structure. Union Station is now owned by the USRC, a nonprofit organization that protects the federal government's interests and preserves the history of the station. (Courtesy of Brian Cooper.)

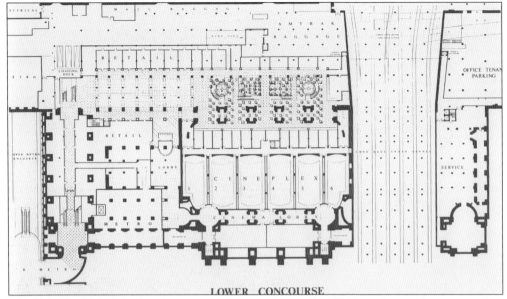

LOWER CONCOURSE

The floor plan shows the lower concourse as it was designed in 1988, with a six-theater cineplex, retail stores, Amtrak baggage areas, loading docks, and access to Metrorail. In 2008, the movie theaters closed, and the lower level was transformed into a large food court, providing a variety of quick and inexpensive dining options. (Courtesy of the Commission of Fine Arts.)

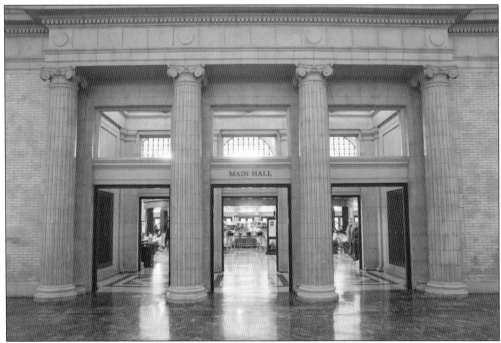

The restoration took two years, with ground-breaking on August 13, 1986, and the reopening on September 29, 1988. Some 300 workers went to great lengths to restore and maintain the unique historical features of Union Station. This photograph shows the decorative features at the entrance to Main Hall. (Courtesy of Brian Cooper.)

This photograph shows a worker repainting the golden eagles that top the flagstaffs in Union Station Plaza. Restoring the station brought pride to the city and reestablished the building as an important landmark and symbol of classical architecture. (Courtesy of the Star Collection, DC Public Library, © *Washington Post*.)

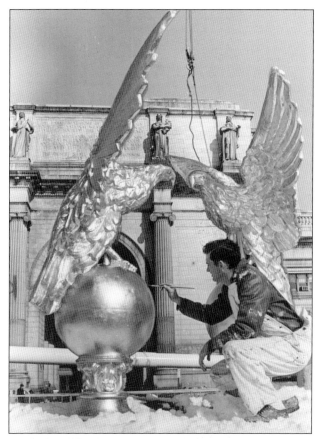

Union Station is a very large building, and the most dramatic transformation was that of the retail space. Three levels were created in the area that was once the concourse. Architects Benjamin Thompson & Associates took advantage of the dramatic arc of the roof and developed a sophisticated shopping space. (Courtesy of Brian Cooper.)

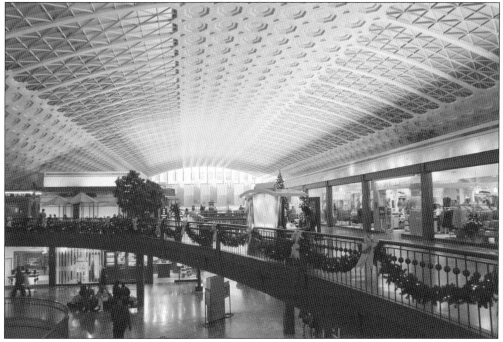

Virginia Railway Express (VRE) began its commuter rail service from Northern Virginia to Washington, DC, on June 22, 1992. VRE connects to Union Station via two lines: the Fredericksburg Line from Fredericksburg, Virginia, and the Manassas Line from Broad Run/Airport station in Bristow, Virginia. VRE runs on rails owned and maintained by Amtrak, Norfolk Southern, and CSX Transportation. The rail service operates Monday through Friday only. VRE riders may also commute using the Cross Honor agreement, which allows VRE riders to use Amtrak as well as reverse-flow MARC trains. VRE is a transportation partnership of the Northern Virginia Transportation Commission (NVTC) and the Potomac and Rappahannock Transportation Commission (PRTC). (Both, courtesy of John Gervasi Photography.)

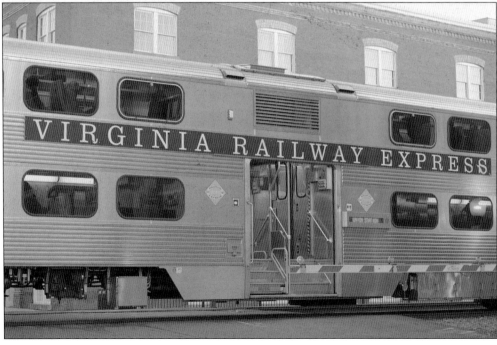

Seven

UNION STATION TODAY

For the past century, Union Station has stood as a symbol of the importance of transportation in the nation's capital. On October 4, 2008, Washington celebrated the Union Station centennial, honoring the historic landmark's role in Washington, DC, over the last century while celebrating the 20-year anniversary of its redevelopment in 1988. The centennial celebration included an open house with exhibits and displays of historic locomotives and current Amtrak trains. (Courtesy of Amtrak.)

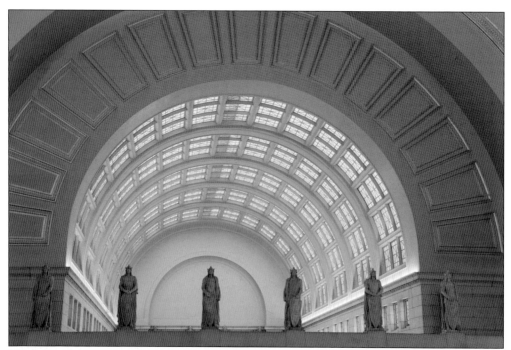

Union Station was magnificently restored while retaining many of the historic structure's unique and grandiose features. This semicircular window invites light into the station's West Hall, silhouetting a row of soldiers sculpted by Louis St. Gaudens. (Courtesy of Brian Cooper.)

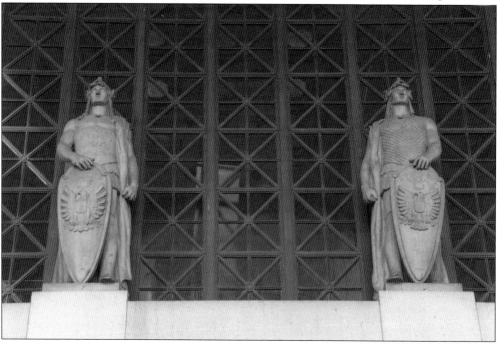

The sculptures of soldiers resemble second-century warriors from Gaul who served as mercenaries in the Roman army. Today's visitors to Union Station appreciate the restored architecture that reminds them of the past. (Courtesy of Brian Cooper.)

Architect Daniel Burnham admired Greek and Roman classical designs and modeled the archways of Union Station after Rome's Arch of Constantine. Today, the archways remind visitors of the proximity of city's train station to the nation's center of power. They are a splendid architectural feature and a comfortable shaded place to wait for a taxi or to meet friends or business associates. (Courtesy of Brian Cooper.)

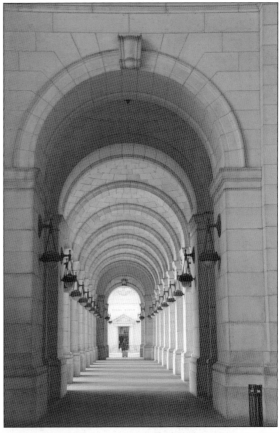

The Welcome Booth, or information center, is located just inside the Main Hall by the front entrance to Union Station. Visitors can find information about the city and the station and can purchase tickets to Old Town Trolley Tours. Sightseeing tours begin at Union Station and highlight the history and interesting facts about Washington's major attractions, such as the Smithsonian Institution, Lincoln Memorial, Jefferson Memorial, Vietnam Veterans Memorial, Georgetown, Washington National Cathedral, the White House, and more. (Courtesy of Brian Cooper.)

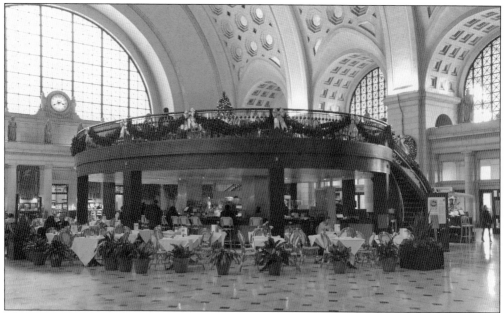

The Center Café Restaurant is a two-story eatery that occupies the central space of the Main Hall and offers a 360-degree view of Union Station's historic spaces. The restaurant is owned and operated by Ark Restaurants and serves contemporary American cuisine, including breakfast, lunch, and dinner. This beautiful space was created during the 1988 renovation of the station. (Courtesy of Brian Cooper.)

Alamo Flag Company operates a kiosk in the Main Hall at Union Station that sells flags, banners, fixtures, apparel, and a variety of patriotic accessories. The store is one of several retailers that provide souvenirs for visitors to the nation's capital. (Courtesy of Brian Cooper.)

The departure and arrival schedules are posted on an electronic board outside the Amtrak train terminal. Although delays still occur due to changing weather and other unforeseen circumstances, modern technology allows travelers to be more informed and plan their schedules according to up-to-date information. (Courtesy of Brian Cooper.)

As an alternative to waiting in the ticket line, travelers can purchase Amtrak tickets at a Quik-Trak kiosk. The machines are easy to use and print out tickets instantly. A credit card can be used to activate the kiosk and enter a reservation number, or the barcode on a confirmation page or e-mail can be scanned at the kiosk. (Courtesy of Brian Cooper.)

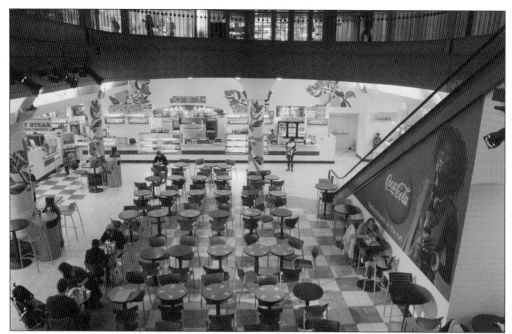

The lower level of Union Station is a food court offering a casual place to enjoy a snack or take the whole family for a quick and inexpensive meal. More than 25 fast-food vendors offer sandwiches, salads, pizza, burgers, ice cream, and more. Dining at the food court is a great option for visitors on a budget or for those waiting for a departing train. (Courtesy of Brian Cooper.)

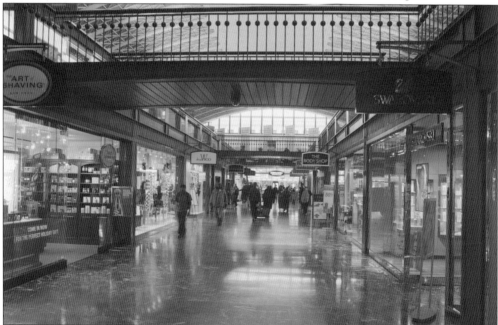

Today, Union Station includes a premier shopping mall with more than 130 stores featuring everything from men's and women's fashion to jewelry to decorative arts to games and toys. Among the well-known stores are Ann Taylor, Chico's, Barnes & Noble, Godiva Chocolatier, the Body Shop, Jos. A. Banks Clothiers, Swatch, and many more. (Courtesy of Brian Cooper.)

The gates and waiting rooms for Amtrak offer modern seating and plenty of open space for travelers to watch their luggage while they wait. The ceiling was designed to let in natural light and provide a comfortable reading or lounging space. The gates are located in the back side of the building near the train platforms. Passenger services are nearby, such as car rental desks, travelers' aid, and shoe shine services. Food vendors such as Ben and Jerry's Ice Cream and Starbucks are within a short walk. (Courtesy of Brian Cooper.)

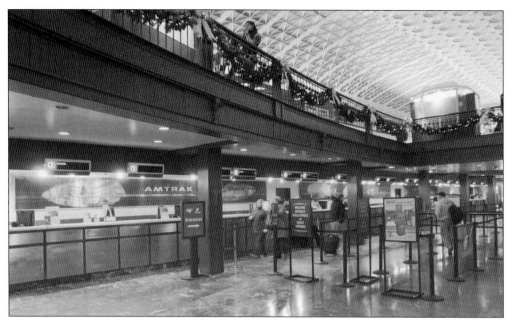

The Amtrak ticket counter is a modern space with the latest technology. Ticket agents are available to answer questions, although most people skip the line and purchase their tickets in advance online or in person from one of Amtrak's self-service ticketing kiosks. (Courtesy of Brian Cooper.)

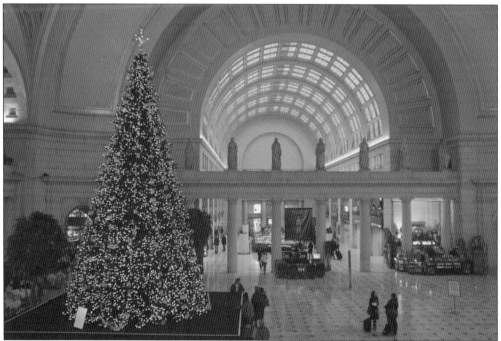

Visitors enjoy the annual Christmas tree-lighting ceremony, the holiday model train display, and seasonal shopping at Union Station. The station is beautifully decorated for the holiday season and makes a great place to enjoy Christmas carols and holiday cheer in the nation's capital. (Courtesy of Brian Cooper.)

Large wreaths are hung from each archway in the front of Union Station, giving the building a festive look for the holiday season. Thousands of visitors travel through the station, enjoy some holiday shopping, or attend seasonal parties at many of the restaurants within the Great Hall. (Courtesy of Brian Cooper.)

Visitors enjoy the annual Norwegian Christmas model train display throughout the holiday season at Union Station. The trains wind their way through the mountains and fjords of Norway. The Marines, mayor, city officials, and the Norwegian ambassador jump start the train in an official launching ceremony and kick off the Toys for Tots donation drive in early December. (Courtesy of Brian Cooper.)

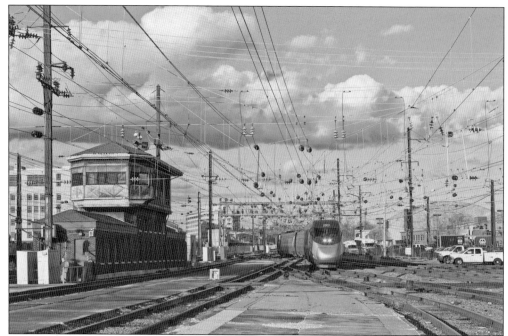

In March 2000, Amtrak introduced the Acela regional passenger service, creating the long-awaited electrification of the Northeast Corridor linking Boston, New York, and Washington, DC. The Acela Express, the nation's first high-speed rail system, significantly reduced the travel time between these major cities by moving at speeds up to 150 miles per hour—reducing a Boston–to–New York trip to 3 hours and 15 minutes and a New York–to–Washington trip to 2 hours and 28 minutes. The photograph above shows the *Acela* passing K Tower arriving at Washington's Union Station. The image below shows a close-up of the *Acela* parked at the terminal. (Above, courtesy of Amtrak; below, courtesy of Brian Cooper.)

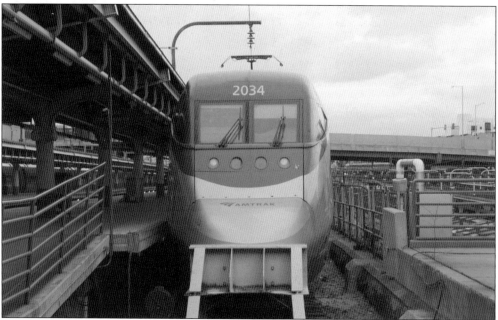

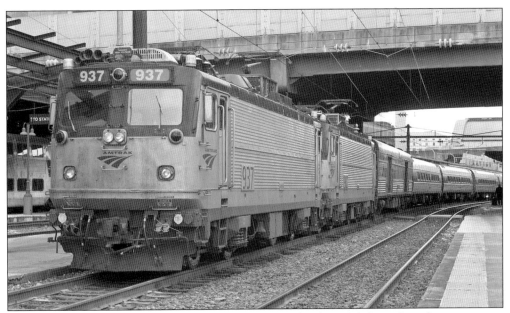

Today, Amtrak operates in 46 states, the District of Columbia, and three Canadian provinces, with more than 300 trains traveling each day at speeds up to 150 miles per hour. The *Silver Star* is a 1,522-mile passenger train route that runs from New York City to Miami, Florida, with stops in Philadelphia, Pennsylvania; Baltimore, Maryland; Washington, DC; Richmond, Virginia; Raleigh, North Carolina; Columbia, South Carolina; Savannah, Georgia; Jacksonville, Florida; Orlando, Florida; and Tampa, Florida. Services on the Silver Service trains include Viewliner Sleeping, dining car accommodations, and reserved coach class seating. The *Silver Star* departs daily. There are six Silver Service trains, numbered 89, 90, 91, 92, 97, and 98. (Above, courtesy of Amtrak; below, courtesy of Brian Cooper.)

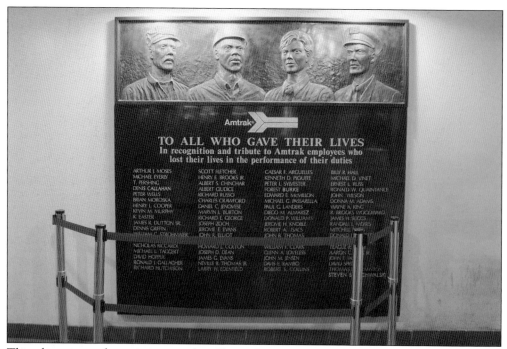

This plaque near the train terminal in Union Station is a touching and honorable tribute to Amtrak employees who lost their lives while on duty. More than 70 employees are remembered for their dedication to the railroad. (Courtesy of Brian Cooper.)

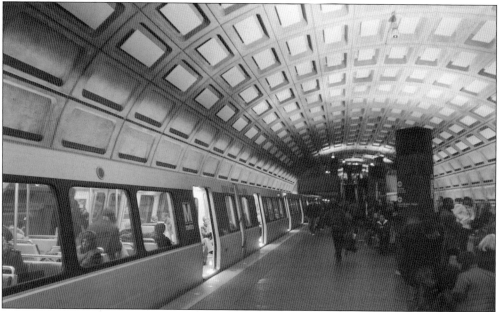

In 2010, Metrorail serves 86 stations and has 106 miles of track and a fleet of more than 1,100 rail cars. Visitors from destinations all across the East Coast arrive by Amtrak and can then transfer to Metrorail at Union Station to travel around the Washington metropolitan area. Turning the station into a multimodal transportation depot has served the city well, and Washington has become one of the most popular tourist destinations in the country. (Courtesy of Brian Cooper.)

VRE provides a necessary supplement to commuter transportation from the busy Northern Virginia corridor to downtown Washington. As of July 2010, VRE transports an average of almost 18,000 passengers per day on a total of 18 rail lines. VRE provides commuter service to the outer suburbs like Manassas and Springfield that the Washington Metrorail cannot reach. (Courtesy of John Gervasi Photography.)

Today, the 187-mile MARC system provides commuter service on three lines, between Baltimore, Maryland, and Washington, DC; Perryville, Maryland, and Washington, DC; and Martinsburg, West Virginia, and Washington, DC. MARC trains operate Monday through Friday only and offer limited service on select holidays. All three lines arrive in Union Station. MARC provides inexpensive public transportation to the nation's capital from regional destinations that do not have Metrorail or Metrobus service. (Courtesy of Brian Cooper.)

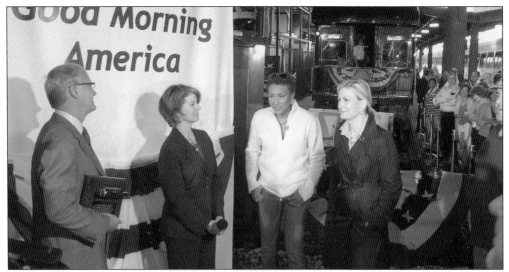

ABC's *Good Morning America* kicked off a pre-election whistle-stop tour at Union Station on September 14, 2008. Diane Sawyer, Robin Roberts, Chris Cuomo, and Sam Champion boarded an antique train at Union Station and headed for Stockbridge as part of ABC News and *USA Today*'s 50 States in 50 Days preelection coverage. In this photograph, from left to right, Amtrak CEO Alex Kummant and board member Donna McLean are about to present a plaque to Roberts and Sawyer. (Courtesy of Amtrak.)

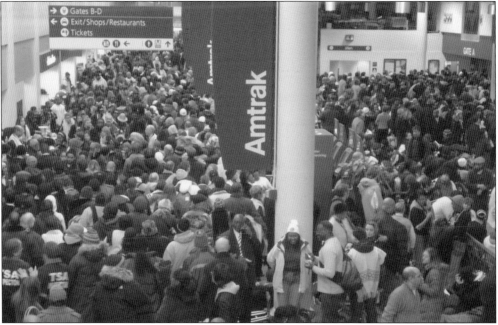

An estimated 1.8 million people attended the 2009 inauguration of Barack Obama, a record-breaking number for any event in the nation's capital. With such a huge turnout, there were many security and transportation challenges. Amtrak, Metro, MARC, and VRE ran at full capacity and provided transportation for the majority of the people who came to the historic event. The interior of Union Station was closed during the day to allow for preparations for the Eastern Inaugural Ball, which was held that evening in the Main Hall. (Courtesy of Amtrak.)

According to Amtrak's Doug Riddell, "Trains can easily plow through all but the deepest accumulations of snow. Wet packing snow and ice sometimes cause delays because they tend to weigh down the overhead electric lines from which trains to and from points north of Washington derive their source of power, and thus, train speeds must be reduced to avoid damaging the catenary (overhead wire) system. At switching points (or interlockings, as they're known on the railroad) where trains move from one track to the other, electric or oil heaters keep rail temperatures warm enough at critical points to help prevent snow or ice build up. Still, with lots of trains moving over those switches, packed snow and ice tend to drop into those critical points, necessitating the use of high temperature forced air blowers to melt and clear the obstructions." (Both, courtesy of Amtrak.)

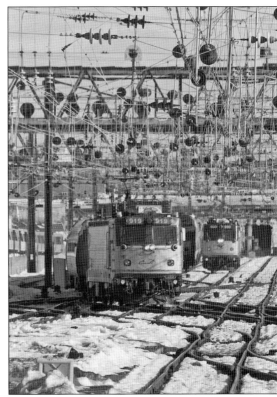

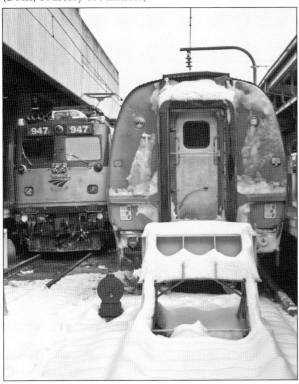

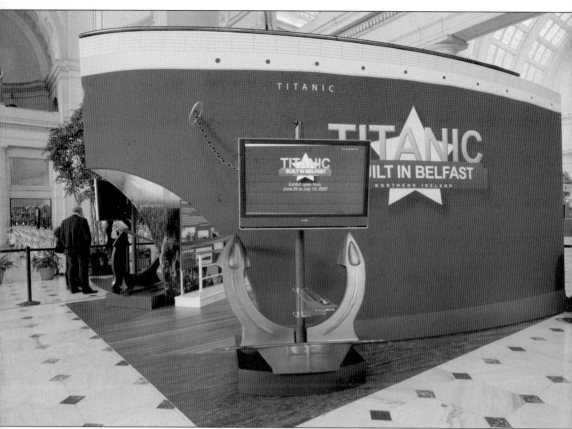

During the summer of 2007, Union Station held an exhibit entitled Titanic: Built in Belfast, which offered a peak into the history of the construction, launch, and disastrous maiden voyage of the *Titanic*, which tragically sank on its voyage from Queenstown, Ireland, to New York City in 1912. Produced by National Museums Northern Ireland and its partner organizations, the exhibit included never-before-seen images of the ship's construction along with exclusive footage of the *Titanic*'s voyage from Belfast. Titanic in Belfast focused on the engineering and technological innovations that went into the creation of the ship. (Courtesy of Hargrove, Inc.)

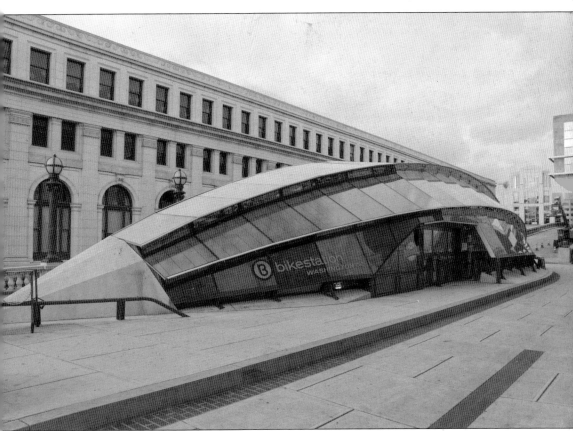

In 2009, Bikestation Washington DC opened at Union Station and offers secure bike storage for members with availability 24 hours a day, seven days a week. The 1,600-square-foot storage facility allows commuters to take public transportation to the station, pick up their bicycles, and go to work, shopping, or entertainment. The facility also provides a changing room, lockers, bike rental, bike repair, and retail sales. The District of Columbia is becoming one of the most bike-friendly cities in the country, and there are 40 miles of newly added bike lanes and more than 800 miles of biking trails throughout the metropolitan region. The city is seeking new ways to help people get around and to protect the environment. Capital Bikeshare, a new regional program, provides 1,100 bikes dispersed throughout the District of Columbia and Arlington, Virginia. Members receive an unlocking code and can return the bike to another location in the city. There is a Capital Bikeshare dock at Columbus Circle in front of Union Station. (Courtesy of Brian Cooper.)

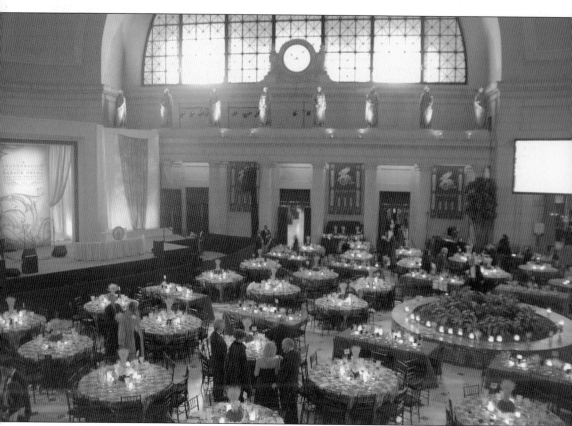

The 1988 remodeling of Union Station created three historic venues for special events: the Main Hall, East Hall, and Columbus Club. The grand Beaux-Arts building and its exquisite architectural features make it a unique location for a dinner, reception, luncheon, or other large gathering. The event sites are available for rental individually or in combinations to accommodate large groups. This photograph shows the tables and decor in the Main Hall elegantly set up for the Obama Inaugural Ball on January 20, 2009. Providing design, decor, installation, and parade floats for a variety of public and private inaugural-related events, Hargrove, Inc., a local event-planning company, has been a significant supplier to presidential inaugural activities since 1949. (Courtesy of Hargrove, Inc.)

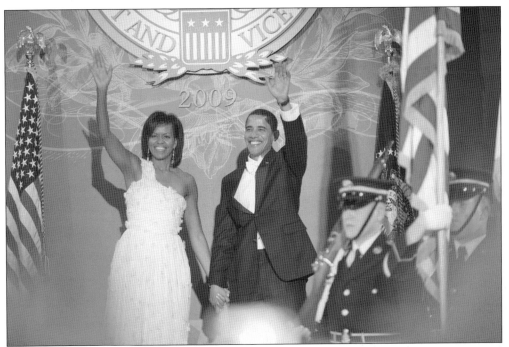

Over the years, Union Station has been the site of countless special events, including six inaugural balls. More than 10,000 people came to toast Pres. Barack Obama in 2009 at the Eastern Inaugural Ball, which included invited guests from Connecticut, Maine, Massachusetts, New Hampshire, Rhode Island, Vermont, Puerto Rico, and the US Virgin Islands. (Courtesy of Hargrove, Inc.)

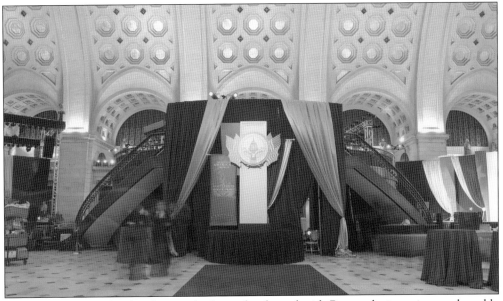

With its 96-foot coffered ceiling, arched portals adorned with Roman legionnaires, and marble floor, the Main Hall offers a dramatic venue for private events. It can accommodate 2,200 seated guests, 4,000 standing guests, and up to 7,500 guests when used in conjunction with other event spaces in Union Station. This photograph shows the Main Hall as it was decorated for 2009 inaugural events. (Courtesy of Hargrove, Inc.)

In 2008, Amtrak began hosting a National Train Day event at Union Station. An annual family-friendly commemoration of America's love for rail travel, the event features live entertainment, interactive and educational exhibits, kids' activities, model-train displays, and tours of notable private railroad cars, Amtrak equipment, and freight and commuter trains. National Train Day celebrates the impact of the train on the country and provides an opportunity for Americans to further understand the influence that rail could have on the future of transportation in the United States. National Train Day festivities are held each May in more than 185 locations across the country. Each city has a locally focused exhibit on display so that visitors can learn about how Amtrak partners with each state to provide specialized service. (Courtesy of Amtrak.)

Amtrak and Disney partnered in 2009 to promote Robert Zemeckis's holiday film *Disney's A Christmas Carol* with a 40-city tour across the country. The *Christmas Carol Train* showcased authentic artifacts loaned from the Charles Dickens Museum in London; artwork, costumes, and props from the film; demonstrations of performance-capture technology; Christmas carolers; and activities for the entire family. (Courtesy of Amtrak.)

Amtrak embraces programs to reduce greenhouse gas emissions and provide energy-efficient transportation. At the Go-Green Express: Eco Exhibit, a part of the 2010 National Train Day event, visitors learned how Amtrak is providing greener options for travel, recycling, conserving resources, cleaning up historical railroad contamination, and protecting the environment. Individual passengers can be eco-friendly and offset their carbon footprints by choosing to use public transportation. (Courtesy of Amtrak.)

Wax figures of all 44 US presidents were gathered at Union Station by Madame Tussauds Washington, DC, to celebrate the launch of its new Presidents Gallery on February 17, 2011. With the opening of the $2-million-plus gallery, Madame Tussauds Washington, DC, will be the only place in the world where people can see and interact with all 44 US presidents. It is a permanent exhibit where guests learn about the history of the United States through the lives of its iconic leaders. Madame Tussauds is a world-renowned wax museum that features interactive exhibits featuring Hollywood, sports, and historical icons. It is located in the heart of downtown Washington, about 1.5 miles from Union Station. (Courtesy of Jim Sulley/Newscast for Madame Tussauds Washington, DC.)

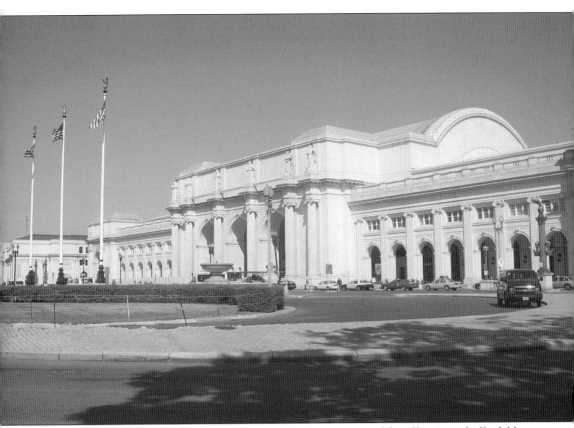

Although the glory days of rail travel have passed, Washington's need for efficient and affordable transportation is greater than ever. The nation is moving toward new high-speed ground transportation, and Union Station will continue to be adapted to meet the future needs of the nation's capital. The historic landmark is now owned by the Union Station Redevelopment Corporation (USRC), a nonprofit organization that protects the federal government's interests and preserves the history of the building. While the original construction of Union Station in 1907 influenced the development of the National Mall, the 1988 restoration of the building played an important role in sparking the redevelopment and modernization of the city's transportation systems as well as its downtown neighborhoods. Washington, DC, is a thriving metropolis with a huge tourism industry and a growing population. Union Station is likely to continue to be a vital component to the city's economic growth. (Courtesy of Amtrak.)

DISCOVER THOUSANDS OF LOCAL HISTORY BOOKS FEATURING MILLIONS OF VINTAGE IMAGES

Arcadia Publishing, the leading local history publisher in the United States, is committed to making history accessible and meaningful through publishing books that celebrate and preserve the heritage of America's people and places.

Find more books like this at
www.arcadiapublishing.com

Search for your hometown history, your old stomping grounds, and even your favorite sports team.

Consistent with our mission to preserve history on a local level, this book was printed in South Carolina on American-made paper and manufactured entirely in the United States. Products carrying the accredited Forest Stewardship Council (FSC) label are printed on 100 percent FSC-certified paper.

MADE IN THE

 USA